T h e DRAWING COURSE A Step-by-Step Guide

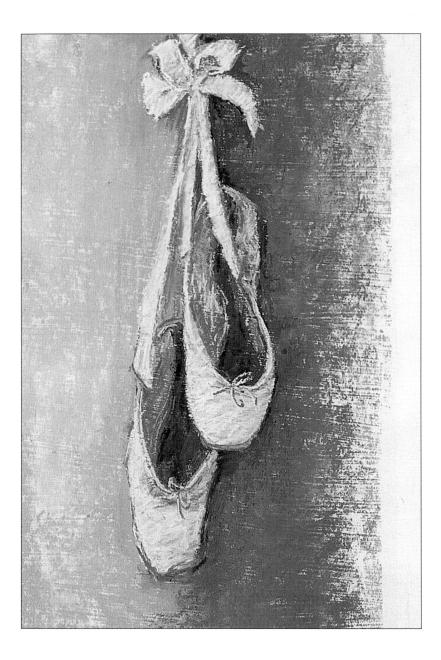

The DRAWING COURSE A Step-by-Step Guide

ANGELA GAIR

Abbeydale Press

First published in 2002 by ABBEYDALE PRESS, an imprint of Bookmart Limited Registered Number 2372865 Desford Road, Enderby Leicester LE19 4AD

© 2002 Bookmart Limited

All rights reserved. No part of this publication may be reproduced, stored in a retrieval system, or transmitted in any way or by any means, electronic, mechanical, photocopying, recording or otherwise without the prior permission of the copyright holder.

Originally published by Bookmart Ltd as part of *The Drawing and Painting Course* in 1996 and as part of *The Artist's Handbook* in 1998.

Reprinted 2002

ISBN 1-86147-094-0

Printed in Singapore

Drawing

Introduction	9
Materials and Equipment	10
Soft Pencils	20
Vegetable Basket	21
Coloured Pencils	26
Vase of Petunias	28
Drawing with Erasers	32
Elephants on Safari	33
Seeing Colour in White	38
Ballet Pumps	40
Crosshatching	44
Beached Boats	45
Broken Colour	50
Wild Flower Field	52
Conté Crayons	56
Baker's Selection	58
Blending	62
Clouds and Rain	64
Line and Wash	68
Red Onions	70
Pastel Pencils	74
By the Sea Shore	76
Charcoal and Chalk	80
Fruits de Mer	81
Frottage	84
Citrus Fruits	85
Graphite Sticks	90
A Study in Textures	91

Index

95

AN INTRODUCTION TO Drawing

PROJECT 1

PROJECT 2

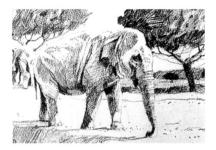

PROJECT 3

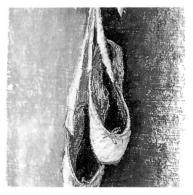

PROJECT 4

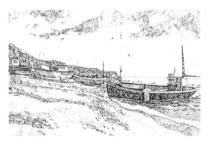

PROJECT 5

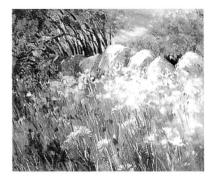

PROJECT 6

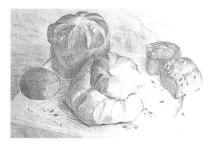

PROJECT 7

PROJECT 10

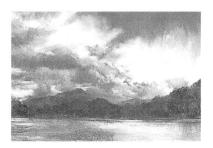

PROJECT 8

PROJECT 11

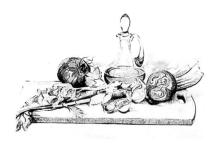

PROJECT 9

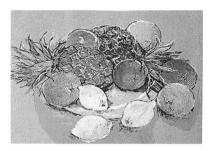

PROJECT 12

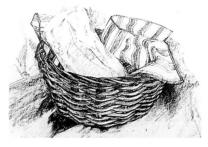

PROJECT 13

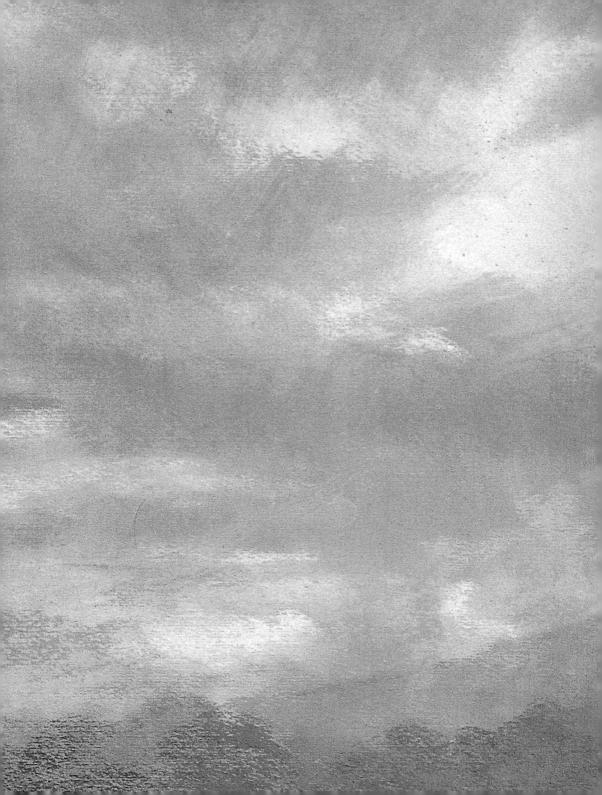

Drawing

There are many reasons for learning how to draw. To begin with, the activity of drawing is a source of much pleasure and satisfaction. Drawings and sketches are infinitely better than taking photographs as a means of recording information for a painting. But most importantly, drawing heightens our visual awareness, helping us to see the world around us with a fresh and enquiring eye.

A vast range of drawing materials, papers and equipment is now available to the artist. Each medium has its own characteristics and the opportunities for personal expression are without limit. Charcoal, for example, is perfect for bold, expressive drawings on a large scale, while coloured pencils are particularly suited to delicate, detailed work on a small scale. Your choice of medium will depend on how you work, and the reason for your drawing. Try to get into the habit of drawing a little every day, experimenting with a range of media and techniques. RAWINO

Materials and Equipment

We usually associate drawing with simple lines drawn with a pencil or pen, but today the term drawing embraces a wide variety of monochrome and colour media which can be used in exciting and expressive ways.

PENCILS

The pencil is the most familiar drawing tool of all. It has a varied range, allowing for soft, velvety tones as well as delicate lines and details.

Ordinary wooden pencils comprise a thin rod of graphite encased in a hollow tube of wood. The graphite rod is known as the 'lead' – a term dating back to the sixteenth century, when graphite was first discovered and was mistakenly thought to be lead. Pencils are graded by the H and B system, according to the relative hardness or softness of the graphite core. Typically, hard pencils range from 9H (the hardest) to H, and soft pencils

Below A range of materials for drawing and sketching, including hard and soft lead pencils, coloured pencils, graphite sticks, a kneaded putty eraser, and a craft knife and glasspaper block for sharpening pencils.

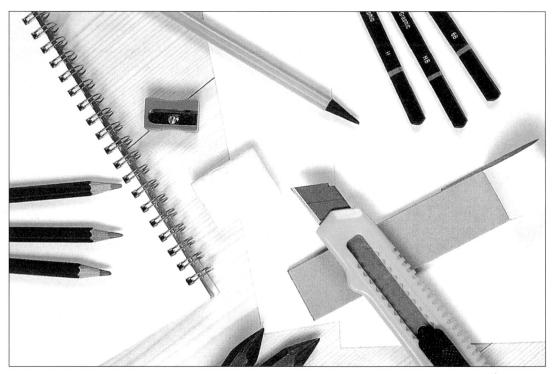

MATERIALS AND EQUIPMENT

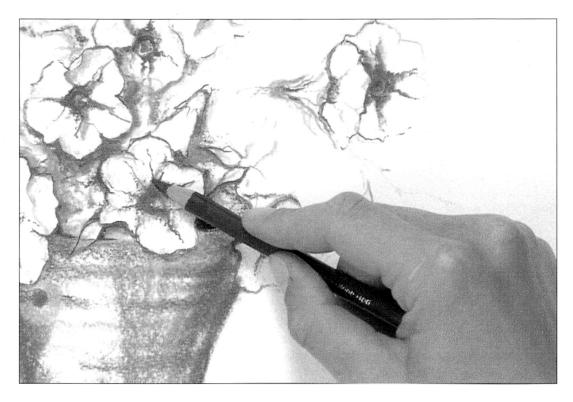

range from 8B (the softest) to B. Grades F and HB are midway between hard and soft A very soft lead enables you to make broad, soft lines, while hard leads can be sharpened to the finest of points and are suited to fine lines and precise details. A medium grade such as 2B or 3B is probably the most popular for drawing.

Other types of pencil include propelling pencils and clutch pencils, designed to take a range of interchangeable leads. These have an advantage over wooden pencils because they don't need sharpening. Carpenters' pencils have a flat, rectangular lead that allows you to make broad, grainy marks as well as thin lines. Extremely soft pencils, known as graphite sticks, are also available. These are quite thick and produce strong, dark marks that are especially effective on rough-textured paper. **Above** It is possible to produce a wide range of tones and textures with coloured pencils simply by applying different pressures to the pencil and by using both the point and the side of the lead.

Use a craft knife or scalpel blade for sharpening pencils; pencil sharpeners often break off the lead just as it is sharpened to a suitable point. A pencil that has been sharpened with a blade will retain its point far longer than one sharpened with a pencil sharpener.

Coloured pencils

An increasingly popular drawing medium, coloured pencils offer the same lively linear quality as graphite pencils, but with the added bonus of colour. The 'lead' or core of a coloured pencil consists of clay, coloured with pigment and bound with wax. Some coloured pencils are softer than others, depending on how much wax they contain. In use, coloured pencils can be overlaid to create visual blending of colours, but they cannot be mixed like paints. For this reason, they are produced in many different colours, shades and tints.

AWING

Water-soluble pencils

These are a cross between coloured pencils and watercolour paints. You can apply the colour dry, as you would with an ordinary coloured pencil, and you can also use a soft watercolour brush dipped in water to dissolve the pigment and blend colours together on the paper to create a wash-like effect.

CHARCOAL

Charcoal is the oldest drawing medium. Prehistoric man used sticks of charred wood from the fire as a tool to draw the outlines of animals on the walls of caves. Today, artists' charcoal is produced from vine and willow twigs charred in special kilns. Charcoal is simple to use and lends itself to expressive, spontaneous work. It also smudges easily, so you must draw with your hand raised off the paper and protect finished drawings with spray fixative. **Stick charcoal** is available in various thicknesses. Thin sticks are suitable for sketches and delicate, detailed work. Thicker ones are better for bold work and for covering large areas quickly.

Compressed charcoal consists of powdered charcoal combined with a binder and compressed into short, thick sticks. It is stronger than stick charcoal and doesn't break so easily, and is also useful for laying in broad blocks of tone. **Charcoal pencils** are made from thin sticks of compressed charcoal encased in wood. They are cleaner to handle and easier to control than stick charcoal, and have a harder texture. They make firm lines and strokes and the tip can be sharpened for detailed work.

Right Charcoal is responsive to the slightest change in pressure, so you can produce lines and tones that vary from delicate grey to deep, positive black.

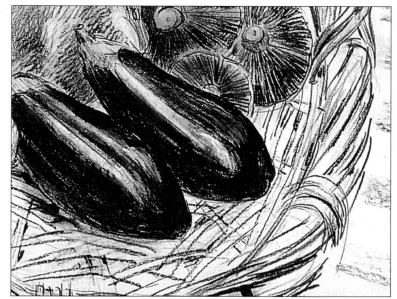

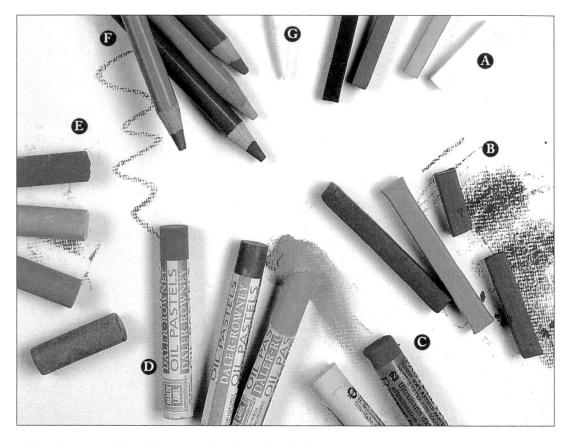

Above Just some of the wide range of pastels and crayons available to the artist. A conté crayons. B hard pastels. C soft pastels. D oil pastels. E half-pastels. F pastel pencils. G torchon (for blending).

PASTELS

The main attraction of pastels is their versatility. Available in hundreds of different colours, they can be pale, soft and velvety or bold and powerful. Pastels are made from finely ground pigments bound together with gum to form a stiff paste, which is then shaped into round or square sticks and allowed to harden. Four main types are available: **Soft pastels** are the most widely used of the various types because they produce the wonderful velvety bloom that is one of the main attractions of pastel art. They contain more pigment and less binder, so the colours are vibrant. The smooth, thick quality of soft pastels produces rich, painterly effects. They are easy to apply, requiring little pressure to make a mark, and can be blended and smudged with a finger, crumpled tissue or paper stump (torchon).

Hard pastels contain less pigment and more binder than the soft type. Although they have a firmer texture, the colours are less brilliant. Hard pastels can be sharpened to a point with a blade and used for crisp lines and details. Unlike soft pastels, they do not crumble and break easily, nor do they clog the tooth of the paper, so they are often used in the early stages of a drawing to outline the composition, or for adding details at the end.

Pastel pencils are thin pastel sticks encased in wood, like ordinary pencils. They are clean to use, do not break or crumble as traditional pastels do, and give greater control of handling. Pastel pencils are perfect for line sketches and detailed small-scale work, and can be used in conjunction with stick pastels.

Oil pastels are different in character from traditional pastels. The pigment and chalk are combined with an oil binder instead of gum, making the sticks stronger and harder. Oil pastels make thick, buttery strokes and their colours are clear and brilliant. Though not as controllable as soft pastels, they have a robust quality that makes them ideal for direct, spontaneous working.

Tints and shades

Pastel colours cannot be mixed before use as paints can, so each individual pastel colour

comes in a wide range of tints (light tones) and shades (dark tones). The paler tints are achieved by adding progressively more white pigment to the full-strength colour, and the darker shades by adding black.

The tonal range of each colour is indicated by a system of numbering that corresponds to the various strengths of each colour. The paper label on a pastel stick bears the pastel's colour and tint number; before you throw it away, rub some colour onto a sheet of paper and write the colour name, tint and brand alongside it. This way, when you come to re-stock your colours you will know exactly which ones to buy.

CONTÉ CRAYONS

These are small, square sticks of very high grade compressed chalk, slightly harder and oilier than pastels. They are also available in pencil form. Traditionally used for tonal drawings, conté crayons were in the past limited to black, white, grey and three earth colours – sanguine, sepia and bistre. Recently a wide range of subtle colours has been introduced, available individually or in boxed sets.

> Left Pastels and chalks have the advantage of speed and directness. There are no colours to be pre-mixed, no brushes or palettes to clean, no drying times to worry about. In short, there is nothing to get in the way of your direct response to the subject.

PENS AND INKS

Thanks to recent manufacturing developments, there is a limitless range of pens and inks available, allowing you to produce anything from a simple monochrome sketch in black Indian ink to a detailed study in brilliant colours.

Drawing inks

There are two types of drawing ink: water-soluble and waterproof. Both types come in a wide range of colours as well as the traditional black. With water-soluble inks the drawn lines can be dissolved with water and the colours blended. With waterproof inks the lines remain intact and will not dissolve once dry, so that a wash or tint on top of the drawing may be added without spoiling the linework. Waterproof inks should never be used with reservoir pens as they contain shellac, which will clog the pen as it dries.

Coloured inks come in a range of brilliant colours. However, they are made from dyes rather than pigments and are therefore not light-fast. To minimize fading, protect finished drawings from prolonged exposure to bright daylight.

Pens

Pens made from natural materials – quills, reeds and bamboos – have been used for centuries. They are light, flexible and responsive and produce lively, animated marks.

Simple dip pens consist of a holder which can be used with a selection of nibs. They produce flowing lines that can be made to swell and thin by varying the pressure applied to the nib.

Fountain pens with their built-in supply of ink are useful for outdoor sketching because they don't need to be dipped into ink repeatedly. They are smoother to draw with than dip pens, but the nib range is more limited and most fountain pens require water-soluble ink to prevent them clogging.

Fibre-tipped pens and marker pens are available in a wide range of colours. Technical pens have tubular steel nibs that produce a controlled, even line and are suited to detailed line work.

Right Drawing with pen and ink is an excellent discipline because it forces you to observe your subject carefully and make a committed mark – you can't rub out your mistakes!

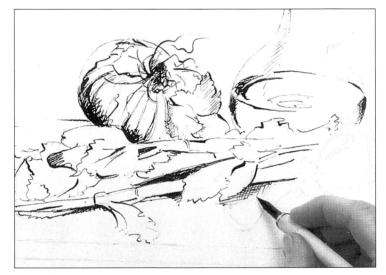

MATERIALS AND EQUIPMENT

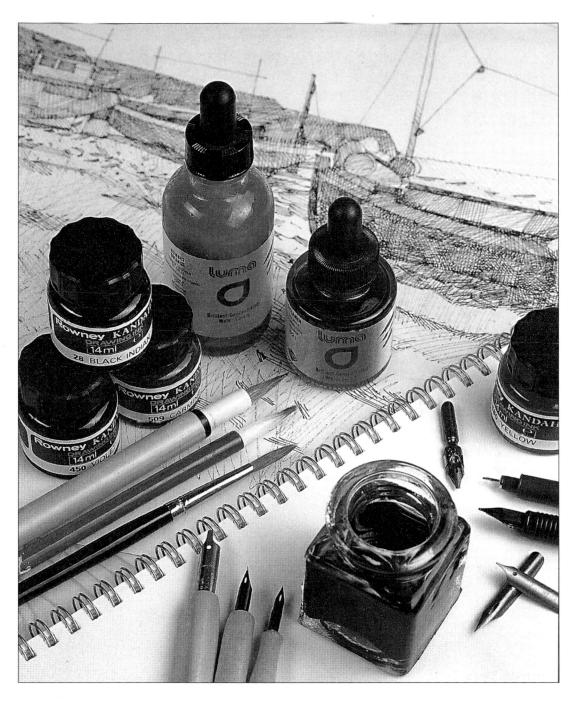

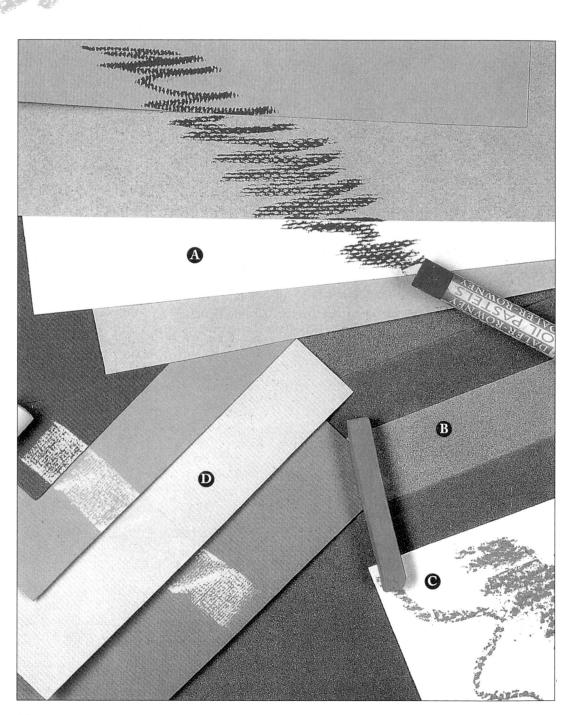

DRAWING

PAPERS FOR DRAWING

Drawing paper is available in a wide range of weights, textures and colours, and can be purchased as single sheets, pads, sketchbooks or boards, which provide a firm support.

The character of the paper can influence a drawing quite dramatically, so it is important to choose carefully. It is worth exploring the effects of a single medium on different papers as they can vary enormously.

Textured paper

Powdery media such as pastel and charcoal need a support with enough surface texture, or 'tooth', to hold the particles of pigment. Smooth papers are unsuitable because the pastel or charcoal stick slides around and the marks are easily smudged. Papers for pastel work come in different textures, from soft velour paper that gives a rich, velvety effect, to rough sand-grain paper which is suitable for bold, vigorous work. The two best-known papers for pastel drawing are Ingres, which has a laid pattern of narrow lines and Canson, which has a fine 'wire-mesh' pattern. A wide range of colours is also available; in pastel painting, areas of the paper are often left untouched, and contribute to the picture.

Smooth paper

Hot-pressed, smooth paper is recommended for detailed work in pencil and pen and ink. Ordinary cartridge paper is fine for most purposes, but fine-nibbed pens work best on a coated paper or line board. These have a very thin, hard coating of china clay which helps to produce crisp, clean lines.

Left Pastel papers come in a vast range of colours and textures. A Canson paper. B pastel board. C rough-surfaced watercolour paper. D Ingres paper.

DRAWING ACCESSORIES

Erasers For erasing, plastic or kneaded putty erasers are best, as the familiar India rubber tends to smudge and can damage the paper surface. Putty erasers are malleable; small pieces can be broken off and rolled to a point to reach fine details. Use them on soft graphite, charcoal and pastel drawings, both to erase and to create highlights.

Paper stumps Also called torchons, these are used for blending or shading charcoal, pastel or soft graphite drawings. Made of tightly rolled paper, they have tapered ends for working on large areas of paper and a sharp point for small details.

Knives and sharpeners You will need a sharp craft knife or scalpel for sharpening pencils and cutting paper. A pencil sharpener is convenient, although a knife is preferable as it gives a longer point and is less liable to break the lead of the pencil. Sandpaper blocks, consisting of small, tear-off sheets of sandpaper stapled together, are useful for getting fine points on graphite sticks, pastels and charcoal sticks. Drawing board If you usually draw on sheets of loose paper you will need a firm support to rest on. You can buy a commercial drawing board at an art supply store, but it is far cheaper to get a good piece of smooth board from a timber merchant.

Fixative If you are using pastel, chalk, charcoal or soft graphite pencils, the best way to preserve and protect your drawings is to spray them with fixative. This varnish-like fluid binds the particles of pigment to the surface of the paper so they will not smudge, smear or shake off. Fixative is available in aerosol spray form or in atomizers that you hold in your mouth and blow through to create a fine spray. A W I N G

Soft Pencils

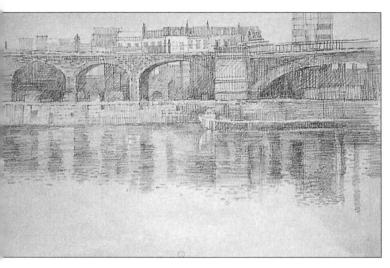

Pauline Fazakerley LIMEHOUSE BASIN Armed only with a soft pencil and a sketchbook, the artist was able to work on site and gather all the information she needed for a watercolour painting to be done back at the studio. The subtle nuances of tone are achieved with varying densities of batching and crossbatching.

Artists' pencils come in various grades, ranging from the softest (8B) to the hardest (9H), with F and HB being in the middle. Hard pencils make fine, silvery lines appropriate for delicate and detailed drawing. Soft pencils are more versatile as they give more varied lines and tones. When sharpened to a fine point, they make fluid lines that can be tapered from thick to thin. When blunt, they make broad, grainy marks and you can use the side of the lead to produce solid areas of tone. You can also blend and smudge the marks laid down to produce subtle, amorphous tones and gradations, then rub back to the white paper with the corner of a kneaded putty eraser to create highlights.

Techniques

The immediacy, versatility and sensitivity of pencils make them the most popular instrument for drawing. Pencil lines can be soft and sinuous, vigorous and bold, or controlled and crisp. The character and nuance of a pencil line will be influenced by the hardness or softness of the pencil lead, the sharpness of the tip, the pressure applied and the speed with which the line is drawn.

Regular practice makes you familiar with the different marks you can produce with a pencil, and improves your drawing skills at the same time. Try to avoid making solid, continuous outlines when you draw. Grip the pencil well back from the drawing point and start by making light, exploratory marks, feeling your way into the shapes and forms you are drawing. Use fluid, fast-moving lines, and let the pencil 'dance' over the paper. Don't worry about the number of lines you make – working in pencil allows for as much elaboration and reworking as you like; in fact, some artists prefer not to rub out their mistakes and re-workings, as these give animation and life to the finished drawing.

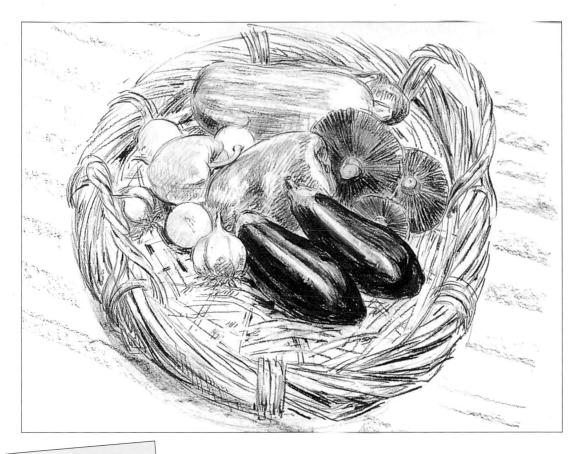

YOU WILL NEED ✓ Sheet of good quality cartridge paper,

cartriage F^A 16¹/₂ x 13¹/₄in (42 x 34cm)
✓ 6B pencil
✓ White chalk
✓ Compressed charcoal
✓ Putty eraser
✓ Drawing board
✓ Drawing pins or tape

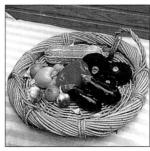

Vegetable Basket

One grade of pencil is enough to make many

different kinds of mark. Soft pencils, in particular, can produce both expressive linear marks and soft, velvety tones – as in this still-life drawing, which contains lively contrasts of tone and texture.

RAWING

Fix the paper to the drawing board with pins or tape. Grip the pencil well back from the drawing point and hold your hand off the paper surface. Working freely from your elbow, sketch in the main outlines of the still life, drawing the basket first and then the vegetables. Keep your lines loose and light, so you can rub out any errors easily. Don't concentrate on any one area for too long – keep your pencil moving over the paper and try to keep the whole thing going at once, letting the image emerge gradually.

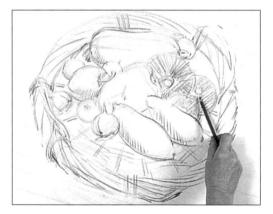

Helpful Hint stand back from your drawing from time to time so you can see how it is taking shape.

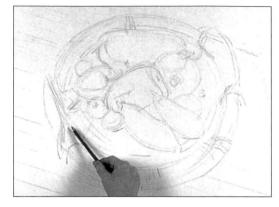

2 Pay attention to the 'negative' shapes between the vegetables, as well as their 'positive' shapes – it will help to ensure the accuracy of your drawing. When you are happy with the composition, start to define the form and volume of the vegetables, using darker lines to emphasize the bulging curves of the marrow and aubergines. Suggest the weaves and plaits of the wicker basket and start to shade in the shadows on the vegetables with loose, hatched strokes. Use the same technique to draw the dark gills of the mushrooms. Keep referring to your subject to make sure the proportions are right, correcting any mistakes as you go along.

3 Shade in the basket and aubergines with bold pencil strokes, using the side of the lead to make soft marks. Now smudge the shading lines with your fingertips to create softly blended tones that suggest the rounded forms. This adds 'colour' to your drawing – it's like painting with a pencil.

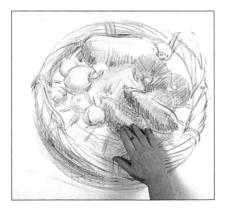

SOFT PENCILS

Continue to build up the darkest tones, using more pressure on the pencil. Vary the type of marks you make, suggesting not only form but also colour, surface pattern and texture. Again, work from one area and back again so that the drawing emerges as a unified whole. Notice here how the vegetables at the front of the group are more detailed and have stronger contrasts of light and dark tone than those at the back. This creates the illusion of depth and prevents the picture from 'tilting' forward.

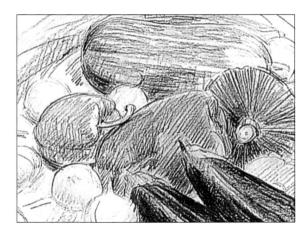

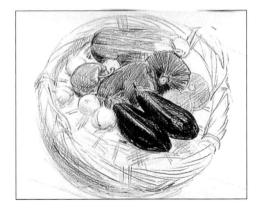

5 The shading on the marrow is done with loose, horizontal strokes that suggest the striped markings. For the peppers, use vigorous hatched strokes, pivoting from the wrist to make the lines follow their curved forms. Leave areas of white paper untouched for the lighter colours and highlights.

Using the side of the pencil lead, shade across the aubergines to describe their dark, shiny skin; smudge the pencil into the paper with your fingertips.

Helpful Hint once you have arranged your still life, don't rush to start drawing but first take a good ten minutes to observe your subject closely, looking at the varying shapes of the objects and the shadows they make.

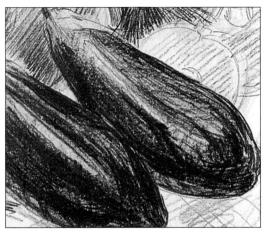

AWING

Now add characteristic detail to the objects in the still life, using both the side and the point of the lead. Move across the drawing, working on all areas at the same time. Build up the shapes and textures of the onions and garlic with line and tone. Draw in the weave of the basket more firmly. varying the pressure on the pencil to suggest light and shade. Then use a sharp corner of a putty eraser to lift out soft highlights on the shiny skins of the vegetables.

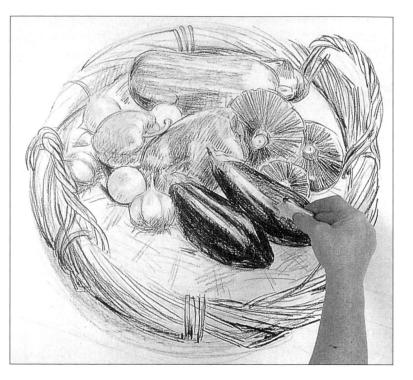

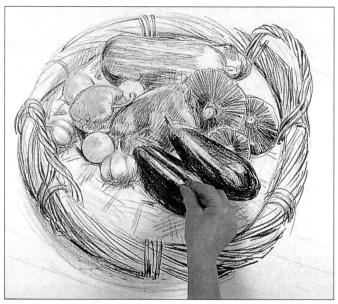

Work white highlights into the drawing with chalk. Concentrate

especially on the dark aubergines at the front of the group, creating strong highlights to bring them forward in the picture plane.

Helpful Hint

WHEN USING SOFT PENCIL, CHARCOAL AND CHALK, **IT'S A GOOD IDEA TO SPRAY** YOUR FINISHED DRAWING WITH FIXATIVE, TO PREVENT ACCIDENTAL SMUDGES.

SOFT PENCILS

9

Deepen the darkest tones on the peppers, oms and

mushrooms and aubergines with a stick of compressed charcoal, blending it into the drawing with your fingertips. Using the side of the stick, lightly suggest the striped background fabric. Using the tip, block in the shadows between the vegetables and add further texture to the basket weave, especially at the front, to make the basket project forward.

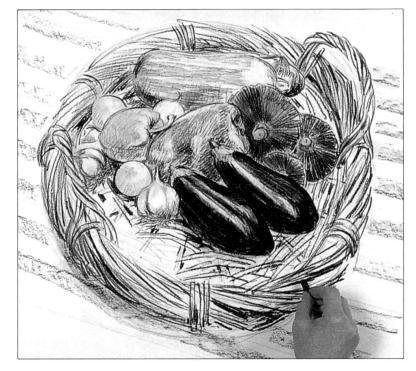

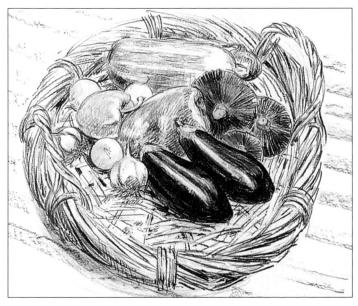

In the finished drawing, notice how the addition of the strong darks makes the light areas appear brighter; these tonal contrasts accentuate the

wonderful textures and forms in the composition, and really bring the picture to life. RAWING

Coloured Pencils

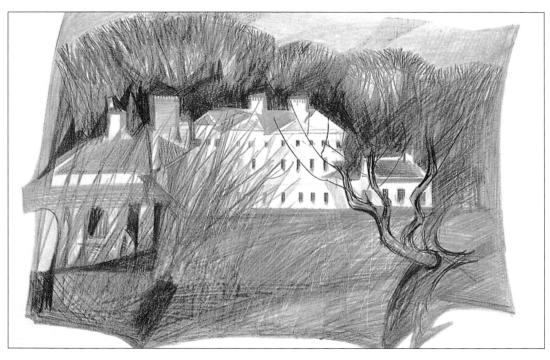

Philip Wildman THE WHITE HOUSE In this lively drawing the artist has applied one colour over another with loosely hatched lines to create a 'broken colour' effect. Notice how the pencil lines are worked in various directions,

encouraging the eye to explore the composition.

Many of us associate coloured pencils with school and consequently underestimate their value to the artist. Being light, portable and easy to handle, coloured pencils are an excellent medium for rapid drawings and outdoor sketches. They are equally capable of creating intricate, highly detailed effects and rich blends of colour. Because the coloured pigment is semi-transparent, light reflects off the white paper and up through the colours, lending them a soft luminosity. Most coloured-pencil drawings are characterized by a lightly textured, delicate finish that is very attractive.

The 'lead' or core of a coloured pencil is clay, coloured with pigment and bound with wax. The higher the wax content, the harder the pencil. Try out different ranges to see which you prefer – they vary in character from soft, chalky and opaque, or soft and waxy, to hard and translucent. With soft pencils, the colour comes off smoothly and evenly. A hard pencil lays down colour quite lightly and is suitable for delicate work. Many artists use COLOURED PENCIL

both types – harder pencils for fine line work and softer ones for laying areas of solid, bold colour and for pastel-like effects.

Techniques

Hold the pencil tightly, close to the point, when laying in small intricate details. To lay in broad areas of loosely hatched colour, hold the pencil loosely, grasping it farther up the shaft and moving it in a natural sweeping motion that finds its own rhythm.

Coloured pencils are most often used on cartridge paper which has a slight tooth. With light pressure on the pencil the colour catches only on the 'peaks' of the irregular surface, producing a subtle granular finish. With heavier pressure the colour is pushed into the 'troughs' of the paper surface. It spreads more evenly and the texture of the paper is slightly flattened, resulting in a smooth, fluid layer.

A rich, 'burnished' effect is achieved by rubbing the colour into the paper surface with firm pressure using the side, rather than the tip, of the lead. The firm pressure applied fuses the colours so that they blend together in a way that is different to that achieved by overlaying colours. The brilliance of the colour can be increased further by rubbing the surface with your finger, a rag or a torchon to produce a

slight sheen. When blending with solid layers of colour the surface of the paper can quickly become clogged, making further layers difficult to apply, so make sure that you choose a textured paper whose surface holds plenty of pigment.

Colour mixing

With coloured pencils you can achieve glowing and shimmering effects using methods such as hatching, crosshatching, shading and scribbling. This creates hues that are richer and more involving to look at than an area of flat colour. For example, strokes of blue laid over yellow make a green that is more subtle, lively and interesting than the flat colour you get by using a green pencil. The pure yellow and blue are still discernible, yet from the appropriate viewing distance they 'read' as green. You can also modulate the green by controlling the amount of yellow or blue.

As with pastels, the best approach is to build up the colours gradually, starting with light, open lines that let plenty of white paper show through. Hatching and crosshatching are a good way to do this because the fine, regular lines give you maximum control over the result.

Jane Strother

STUDY OF APPLES

This drawing was done as an illustration for a magazine article. The artist has skilfully combined delicate watercolour washes with finely hatched coloured pencil lines to define the three-dimensional forms of the apples. Small patches of untouched white paper help to suggest the shiny, luscious texture of the apples' skins.

RAWING

Vase of Petunias

The brilliant colours of this jug of petunias inspired the artist to tackle them using a 'burnishing' technique with coloured pencils. Layers of saturated colour were built up using the sides of the pencil leads, pushing the pigment into the

surface grain of the paper to create a smooth, softtextured finish.

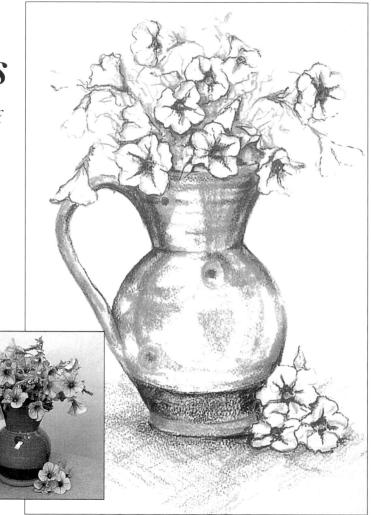

YOU WILL NEED

✓ Sheet of good quality cartridge paper, 16½ x 13¼in (42 x 34cm)

COLOURED PENCILS IN THE FOLLOWING COLOURS

- Sky blue
- Dark blue
- Violet
- Deep violet
- Pale pink
- Dark green

- Yellow-green
- Sepia
- Cinnamon
- Gold ochre
- Wine red

COLOURED PENCII

Start by loosely sketching the main outlines of the composition using the well-sharpened tip of a sky blue pencil. Keep your

lines light and fluid – a solid, continuous outline will make your drawing appear stiff and wooden.

Helpful Hint For this technique it's important that your pencil leads have a smooth edge, so sharpen them with a pencil sharpener and not a craft knife.

3 Continue working on the flowers using a violet pencil. Again, use the side of the pencil lead to create soft tones instead of hard lines. Start at the centres and move out, building up the colour gradually with the side of the pencil lead. Fill in the gaps between the flowers with violet to define the petals and bring the flowers forward. Work on the vase, layering smooth strokes of violet onto the blue underlayer to build up the tones.

22 Switch to a dark blue pencil and pick out the dark areas in the vase, shading with the side of the pencil lead. Shade the dark centres of the petunias with the same colour. Keep your marks light – you'll build up darker colours as the drawing progresses.

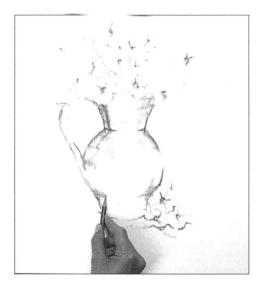

RAWING

Shade gently with a pale pink pencil to suggest the delicate pink veining on the petals and to define their edges. Take some colour down into the vase

of this colour down into the vase.

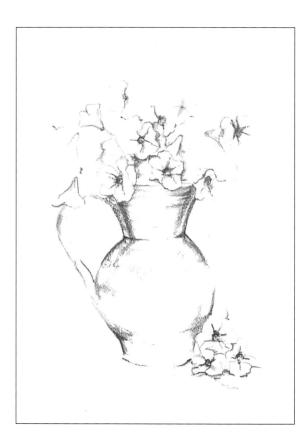

6

Define the foliage between the flowers using dark green and yellow-green. Use dark green to draw the pattern of green n the wave and to indicate the shadow

circles on the vase and to indicate the shadow cast by the vase and the dropped blooms on the green cloth.

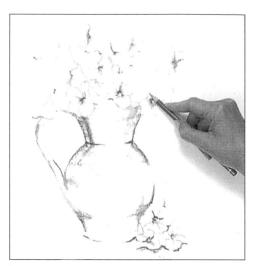

5 Work on the flowers using deep violet, shading over the existing layers of colour to build up the purplish-pink centres. Use the same colour to shade in the dark lines on the individual petals and to deepen the shadows between the blooms.

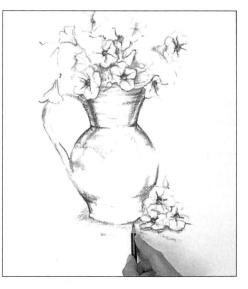

COLOURED PENCIL

Build up the circular pattern on the vasc with strokes of pale pink overlaid with gold ochre. Fill in the centres with violet. Build up the mid tones on the vase with soft strokes of sky blue, following the rounded contours with

sweeping strokes of the pencil. Leave areas of untouched white paper for the brightest highlights.

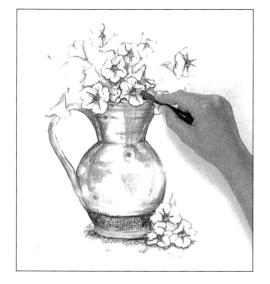

9 Finish off by shading a little more light green into the cloth with the side of the pencil. Add more leaves and stalks between the flowers with strokes of green and add touches of pink to the petals of the flowers in the background.

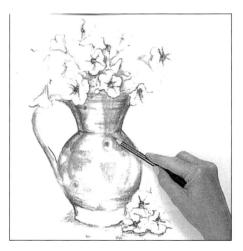

8 Fill in the dark band around the base of the vase with sepia and use cinnamon for the terracotta base. Now use wine red to introduce deeper shading on the jug, for example on the handle and on the rim. Use the same colour to go over the lines on the petals and to outline the flowers in the foreground.

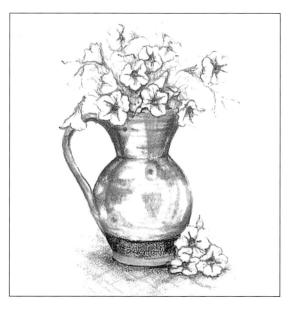

Drawing with Erasers

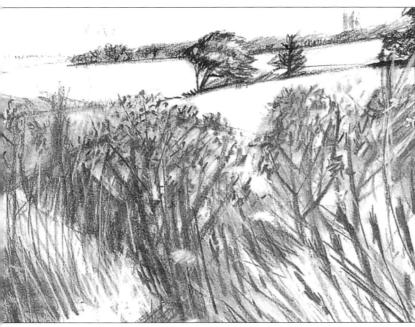

light areas by creating 'negative' lines and shapes.

This technique can be used with any soft drawing medium, such as graphite stick, pencil, or charcoal. It is possible to produce a different mood and surface quality depending on the type of eraser you use and the degree of pressure applied. If you want a gentle, lyrical effect, use a putty eraser and light pressure to produce soft-edged marks that impart a slightly hazy, luminous quality to the finished drawing. For a bolder,

Sarah Donaldson ACROSS THE FIELDS

This is an effective composition, with the tall grasses in the foreground forming the main focus. The artist worked into some of the charcoal marks with a putty eraser to soften the tones and emphasize the upward sweep of the grasses, which leads the eye to the landscape beyond.

Erasers aren't just used for rubbing out mistakes – they can also be used as mark-makers in their own right. For example, rather than leaving the light tones in a drawing blank or partially covered, why not try blocking in a solid area of dark tone and then use an eraser to 'draw' into it, pulling out the highlights and more graphic effect, use a hard eraser and apply more pressure to pull out crisp, angular shapes.

Erasers

There are several types of eraser available, each suited to different functions and different papers. Some work better on hard, glossy papers, while others are more efficient on a soft or textured surface. Putty erasers, or kneaded erasers, are soft and can be used to wipe away broad shapes. Try twisting a corner to a fine point for pulling out fine details. With heavy pressure you can get back to the white of the paper, or you can simply lighten a tone by gently caressing the surface.

Plastic erasers are firm, and their sharp corners are ideal for making crisp, hard-edged marks.

DRAWING WITH ERASERS

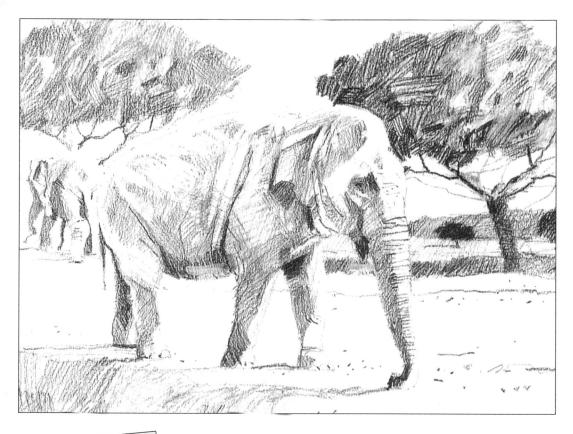

YOU WILL NEED

 Sheet of good quality cartridge paper, 24 x 17in (61 x 43cm)
 Thin and thick sticks of compressed charcoal
 Kneadable eraser

Elephants on Safari

This lively drawing shows how an eraser can be used, not just for correcting mistakes, but also as a drawing tool in its own right. The artist has achieved strong tonal contrasts by building up the shadows with charcoal shading, then using the corner of an eraser to pull out light tones and create a variety of interesting 'negative' shapes.

1

Using a thin stick of compressed

charcoal, sketch the outlines of the elephants and indicate the horizon line.

the outlines of the trees in the background using the edge of the charcoal stick. At this stage any mistakes can be easily removed with a kneadable eraser. Sketch in the foreground elephant's features and the creases on the trunk. Don't use too much pressure with the charcoal or work for too long on any particular areas - the drawing will develop gradually as you build up areas of tone and shading across the paper.

Loosely draw

DRAWING WITH ERASEI

Continue to build up the characteristic features and details

of the elephant's head, using the edge of the compressed charcoal. Work across the body, varying the pressure on the stick to create light and dark lines that indicate the play of light on the folds and creases in the skin.

Using a thicker stick of charcoal, build up the tones on both

elephants to suggest their weight and solidity. Use loosely hatched strokes, leaving bare paper to stand for the highlights. Don't press on to the paper as you work - let the weight of the charcoal stick make the marks. Vary the direction of the strokes to follow the form of the elephants and create the texture of the skin. Shade the tree on the left using the same technique. Spray your drawing with fixative at this stage to avoid smudging the marks you've made so far.

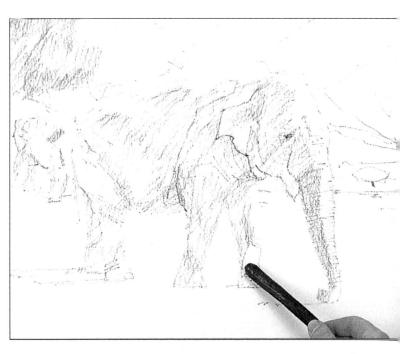

RAWING

Rough in the shadows of the elephants, then continue working with

the thicker charcoal stick to add tone and texture to the foliage and tree trunks. Vary the direction of the strokes and the density of hatching to convey the contrasting textures of the subject. Describe the hills and trees in the distance, which help to emphasize the scale of the elephants. Allow areas of the paper to show through to create highlights where sunlight is striking the subject.

Add more shadows on the body of the background elephant. Switch to the thin charcoal

stick and work back over the large elephant with crosshatching, using finer lines to indicate detail but keeping them spaced apart so that the tone underneath shows through. Darken the distant trees and indicate their cast shadows, and darken the tone on the left side of the tree canopy to indicate strong sunlight coming from the right. The detail (right) shows how the lightly drawn charcoal

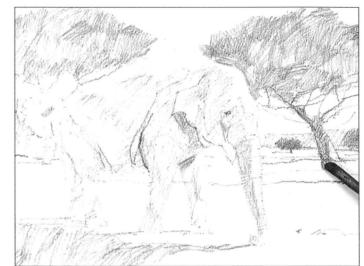

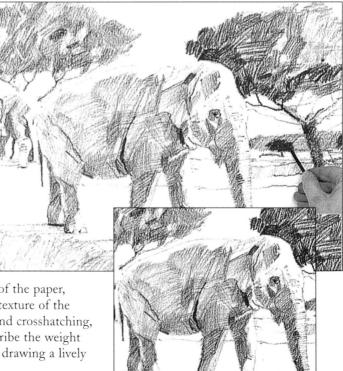

marks are broken up by the texture of the paper, which helps to describe the rugged texture of the elephant's hide. Areas of hatching and crosshatching, running in different directions, describe the weight and bulk of the animal and give the drawing a lively surface texture.

Now start using the kneadable eraser to remove areas of charcoal to introduce more emphatic highlights - for example, where sunlight strikes the elephant's trunk. Work back some of the dark areas with the thin charcoal stick. The strong tonal contrasts thus produced bring the larger elephant forward, increasing the sense of scale and distance. Use the eraser not only to create light and shade but also to convey texture: here, the artist is making sharp angular lines over the elephant's body, emphasizing the folds in its skin.

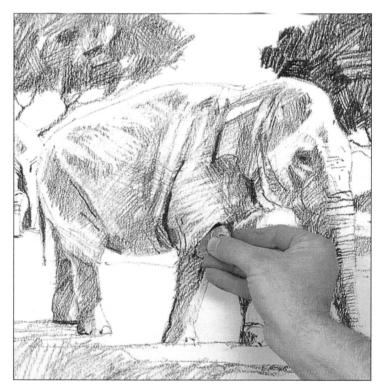

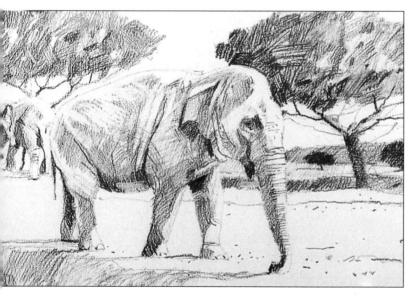

8 To complete the picture, define some of the shadow areas using denser areas of charcoal. Spray the drawing with fixative to prevent smudging. In the final drawing, the lines, shapes, forms and tones all integrate to make a bold, energetic portrait of these splendid animals. AWING

Seeing Colour in White

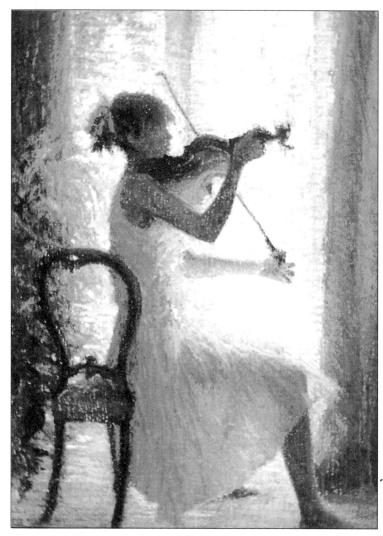

Charmian Edgerton VIOLIN PRACTICE Here a range of blues, pinks and greens 'read' as white in the sitter's dress.

Inexperienced painters often have problems when depicting white objects such as summer clouds, snow, ocean breakers, white buildings, or white clothing in portrait and figure paintings. On the face of it, the task is an easy one; you just use white for the highlights and grey for the shadows. But the resulting image looks flat and monotonous and somehow fails to capture the brilliance and luminosity of the subject.

This problem arises when the artist ignores what he actually sees, and paints instead what he thinks he sees. If you really look closely at a white object, particularly on a sunny day, vou will soon discover that it actually contains a surprising amount of colour, ranging perhaps from warm pinks, yellows and golds in the illuminated parts to cool blues, violets and greens in the shadows. These subtle nuances of colour may not be obvious to you at first.

but it is exactly such unexpected flashes of colour and reflected light that accentuate the brilliance of the whites and give a magical touch of luminosity to a snow scene or a cloudy sky, for example.

SEEING COLOUR IN WHITE

Reflected colour

White has no actual colour of its own but picks up and reflects colours from its surroundings, so that it is almost never really white but a composite of many other colours. White snow, for example, may appear yellowish on a sunny day, while the shadows that fall on it appear blue or violet because they reflect the sky. Similarly, the shadows on a white garment may appear blue or violet outdoors on a sunny day, but indoors under artificial light they may have a greenish or yellowish tinge. As an artist,

you are perfectly free to embellish or exaggerate the colours you see in nature in order to intensify the experience for those who will view your picture. Monet's paintings of snowy winter landscapes, for example, contain barely any white paint; instead he wove together cool but vibrant blues, violets and greens, offset by warm pinks and yellows. Because the colours are juxtaposed in small dabs they merge to give an impression of shimmering whiteness much more evocative than slabs of pure white.

Pastels are particularly good for drawing colourful whites. By applying strokes of different colours side by side or one over the other, it is possible to suggest tiny hints of many hues. Gradually building up the picture with small, broken colour strokes gives it a vibrant quality that suggests the play of light and shadow, and produces rich, complex layers that are far more lively than just plain white.

Jackie Simmonds

FIVE GREEK CATS, LINDOS White buildings reflect a lot of light. In bright sunshine the light is warm and yellowish, and the shadowed areas are correspondingly cool and appear blue or violet. Here the artist has used very pale tints of yellow and ochre, rather than pure white, for the sunlit areas. Yellow-orange is the complementary of blue-violet, and when the two are juxtaposed they enhance each other and create a vibrant effect that effectively suggests bright sunlight.

RAWING

Ballet Pumps

Pastel artists most often work on a coloured ground, but a white ground can work well for delicate subjects. In this study of ballet pumps, flecks of the white paper are glimpsed through the pastel strokes, breaking up the colour and creating a lightness and vibrancy appropriate to the subject.

YOU WILL NEED ✓ Sheet of white, roughsurfaced paper or board 17 x 13½in (43 x 34cm)

Drawing board and masking tape or clips

✔ Charcoal

✔Clean rag

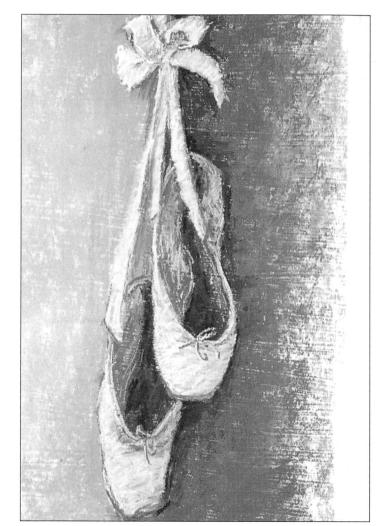

SOFT PASTELS IN THE FOLLOWING COLOURS

- Pale tint of cerulean
- Pale tint of cobalt blue
 Mid tone ultramarine blue
- Dark grey-blue
- Pale violet
- Mid-tone violet

- Deep violet
- Pale tint of viridian
- Creamy lemon yellow
- Bright yellow
- Pale tint of orange
- Pale cream

SEEING COLOUR IN WHIT

Sketch the ballet pumps with charcoal, using a clean rag to gently 'knock back' any excess charcoal dust so that it does not mix with the pastels and make the colours muddy.

Block in the whole background area with pale tints of cerulean and cobalt blue; break off a short length of pastel and use the side, not the tip, to give a fairly even cover. Build up darker blues over this, to give an impression of light and shadow; use a mid-tone ultramarine blue, then overlay it with deep violet and a dark grey-blue for the darkest shadow behind the ballet pumps. Gently blend the colours together with your fingertips to smooth out any hard edges.

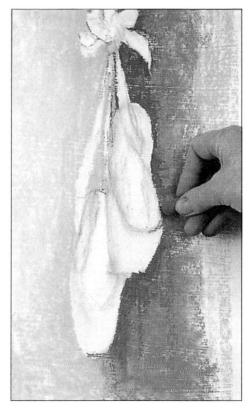

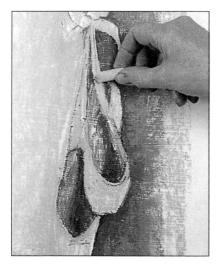

Define the forms of the ballet pumps using three tones of violet. Fill in the insides with a midtone violet, overlaid with deep violet mixed with purple-brown for the dark shadows. For the ribbons and the tops of the pumps, use a very pale violet, as shown. Apply the colours lightly, allowing some of the white paper to show through. This prevents the grain of the paper filling up too quickly, allowing you to add further layers on top.

RAWING

Add touches of pale viridian to the outer edges of the ribbons and the rim of the pumps, where the light catches them. Add hatched strokes of creamy lemon vellow to the bow and the ribbons. Use a little pale orange for the shadows and the folds in the bow. Highlight the toes of the pumps with strokes of creamy lemon yellow and bright yellow. The base layer of pale violet

pastel on the bow will show through in places as you add lively strokes of viridian, orange and yellow (see detail). This bold approach works well with pastel, giving vibrancy to the subject.

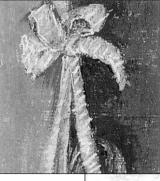

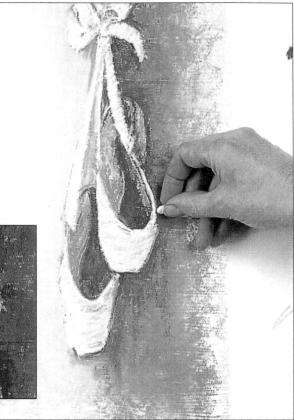

Helpful Hint

WHEN YOU'VE WORN A PASTEL DOWN TO A TINY STUMP, DON'T THROW **IT AWAY - THESE SMALL PASTEL PIECES** ARE IDEAL FOR DRAWING DETAILS AND INTRICATE SHAPES.

Using pale viridian, draw an outline around the rims of the pumps to give them more definition. To do this, break off a piece of pastel and use the sharp edge, as shown. Here you

can see how the rough texture of the paper breaks up the pastel strokes and gives the colours a scintillating quality.

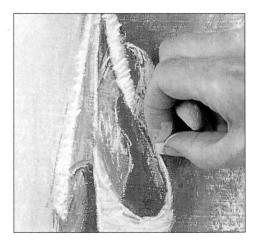

SEEING COLOUR IN WHITI

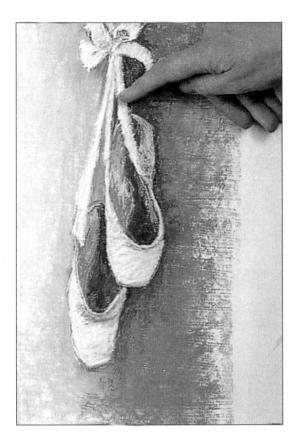

Add a hint of shadow to the toes of the pumps with loose strokes of pale viridian and cobalt blue. Put accents of cobalt blue around the edges of the shoes and into the shadows. Add highlights to the toes of the pumps with strokes of creamy lemon yellow and pale cream. Use your fingertip to gently smooth out the hatched lines on the ribbons; the various tones and colours will blend into each other and create the effect of shiny satin.

Now gently blend the marks on the toes of the shoes with your fingertip to create the same satiny sheen. Don't overblend, though – allow some of the marks to remain, as this gives a more lively effect than smoothly blended colour. Draw the ties at the front of the shoes, using bright yellow for the highlights and cobalt blue for the shadows (you will need tiny slithers of pastel, with a sharp edge, to draw these delicate lines). Finally, add just a touch of definition to the edges of the shoes with deep violet.

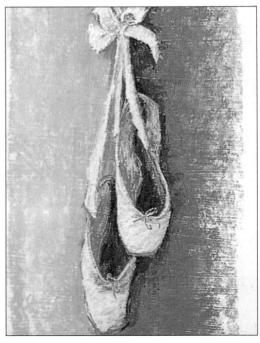

Crosshatching

W I N G

Dennis Gilbert ARCHITECTURAL DETAIL

In this study of a church interior the artist first laid in light watercolour washes, then developed the form, light and shade with different densities of hatched and crosshatched lines, drawn with a dip pen and black ink.

Hatching and also crosshatching have been used for centuries as a means of creating tone and texture in pen-and-ink drawings. In hatching, the lines run parallel to one another; in crosshatching, they cross each other at an angle to create a mesh of tone. Depending on the effect you want, the lines may be carefully drawn or freely sketched.

Considerable variations from light to dark tone can be obtained by varying the pressure on the pen and the spaces between the strokes; the heavier and closer the strokes, the more solid

the tone will appear. Because the white of the paper is not completely obliterated, the tone retains a luminosity that is one of the assests of this technique.

CROSSHATCHING

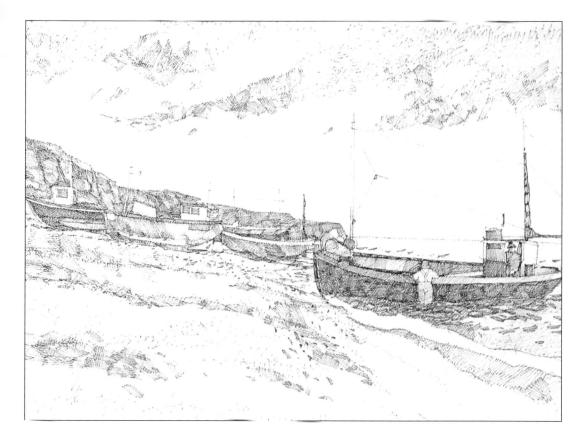

YOU WILL NEED

✓ Sheet of smooth, good quality cartridge paper, 24 x 17in (61 x 43cm)

✓ Black fine-liner pen, size 0.2

✔ H pencil

Beached Boats

An art pen with a very fine drawing tip was chosen for this black and white drawing of beached fishing boats because it produces even, regular lines. Texture and form are achieved by patiently building up small patches of hatched and crosshatched lines. By varying the density of the lines, it is possible to achieve a rich and variable range of tones, from the lightest to the darkest.

RAWING

Lightly draw the main outlines of the scene using a sharp H pencil. When you are happy with your pencil drawing, go over the lines carefully with a size 0.2 black fine-liner drawing pen.

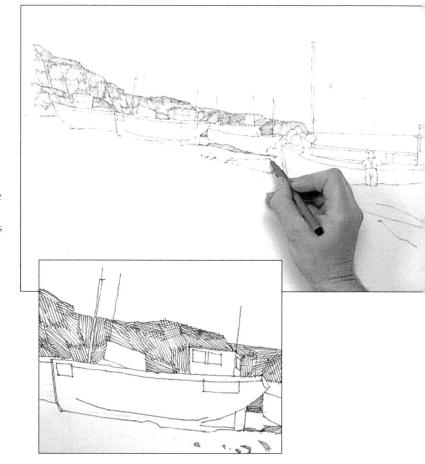

Shade the cliffs in the background by crosshatching the area in small patches, making short vertical, horizontal and diagonal lines to follow the contours of the rocks. Introduce horizontal lines to the darkest areas. The shapes of the boats gradually emerge as the background tones are built up behind them. In the detail (right) you can see how dark areas of tone are built up patch by patch in a series of rapidly drawn vertical. horizontal and diagonal lines. A fine-liner pen moves over the paper quickly and changes direction easily, so it is well suited to crosshatching.

CROSSHATCHIN

Begin working on the three fishing boats in the background. Use lightly hatched strokes for the lightest tones on the boat hulls, then develop areas of denser tone with crosshatching, drawing the lines closer together. Draw the masts and put in the detailing on the cabins. Allow the white of the paper to stand for the lightest tones. A series of short, vertical lines will create the effect of a pebble

beach. Use dots and dashes to indicate the pebbles.

subtle variations of light and shade can be conveyed by varying the pressure on the pen and the density of the crosshatched lines

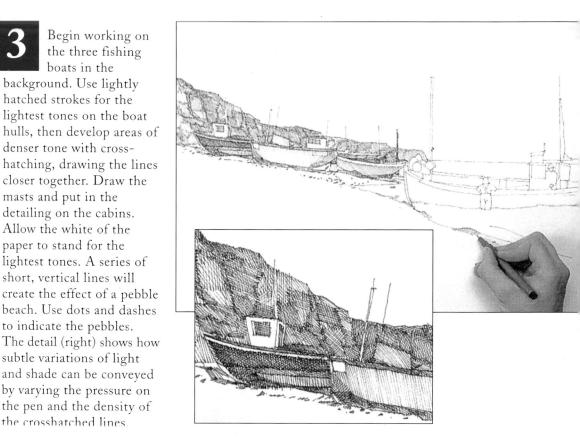

Now build up the detail in the drawing, working back over the boats and the cliffs. By developing all areas at once, rather than concentrating on one area at a time, your

drawing will be unified, with each form relating to its neighbouring forms. Fill in the boat in the foreground using hatching and crosshatching, carefully following the contour of the boat. Draw the cabin, the sailor and the furled sail using short vertical and horizontal strokes to create a range of lights and darks. Suggest the watery reflections on the side of the hull with overlapping patches of crosshatching.

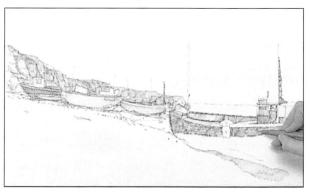

RAWING

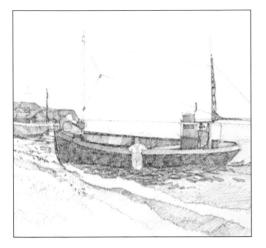

5 Intensify the tone of the foreground boat with a dense mesh of pen lines, to bring it forward in the picture plane. Carefully draw the rigging between the masts with thin, spidery lines – you'll need a steady hand for this! Shade the figure leaning over the side of the boat with a few deft strokes. Indicate the waves lapping the shore with loose crosshatching, leaving bare paper to represent the line of white surf. On top of this, use small patches of darker crosshatching to suggest the shadow cast by the boat on the choppy surface of the water.

6 Draw the rigging on the boats in the background, then suggest the contours of the beach with rapid, scribbled pen strokes worked in different directions. Don't overwork this area – keep it loose and open in contrast with the detailed work on the boat.

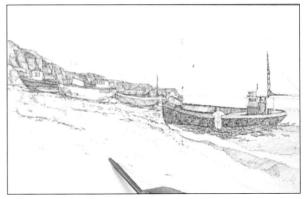

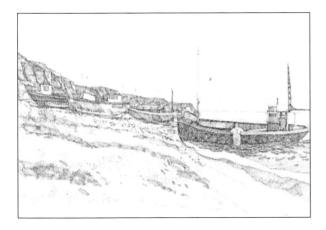

Continue working on the beach, building up the shadow areas by loosely hatching over the scribbled marks. Work back over the drawing, filling in the boats and the cliffs with hatching and crosshatching to convey a strong sense of texture and tonal contrast.

For the sky, you will need to adopt a looser approach in comparison with the

more tightly worked forms of the boats and cliffs. Hold the pen further down the barrel and move it lightly across the paper to create flowing, scribbled marks. Pick out the clouds with more carefully defined areas of hatching and crosshatching. Note how the diagonal lines of cloud echo the diagonal lines of the boats, leading the eye into the picture.

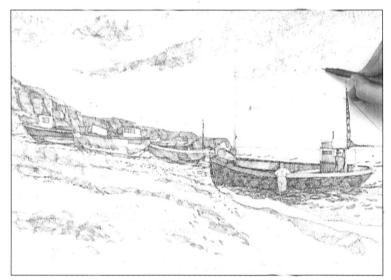

Helpful Hint AVOID OVERWORKING THE IMAGE -THE WHITE OF THE PAPER CONTRIBUTES TO THE IMPRESSION OF LIGHT AND BREATHES AIR INTO THE DRAWING.

Add the final touches, clarifying tones or outlines where necessary. This technique is painstaking and requires a methodical approach, but the results are worth the effort. The final image has a graphic simplicity, and a pleasing mixture of open areas and busy, textured surfaces.

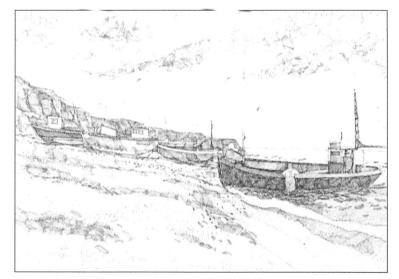

DRAWING

Broken Colour

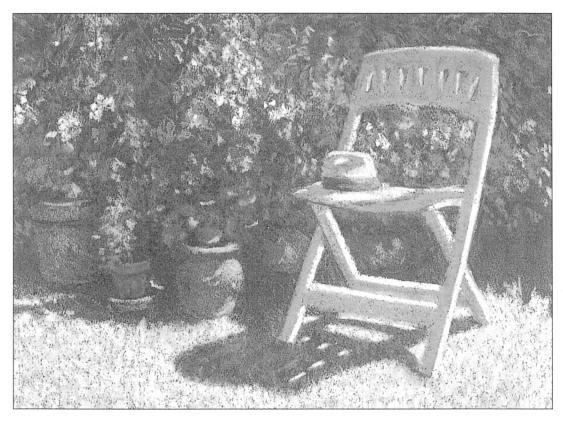

Derek Daniells CHAIR, SUMMER

In this delightful garden scene, vibrant colour combinations suggest the atmosphere of a bright summer day. Each area of the image is formed as a mass of broken colour, consisting of interwoven and overlaid marks.

The term 'broken colour' refers to a method of building up an image with small strokes and dabs of pure colour which are not joined, but leave some of the toned paper showing through. When seen from the appropriate viewing distance, these strokes appear to merge into one mass of colour, but the effect is different from that created by a solid area of smoothly blended colour. What happens is that the small, separate flecks of colour 'vibrate' on the retina of the eye and appear to shimmer and sparkle, giving a more luminous effect than an area of flat colour.

If complementary (opposite) colours are juxtaposed, the effect is even more pronounced. For example, when dots, dabs or strokes of red and green, or yellow and violet, are intermixed, the colours are mutually enhanced by contrast and the effect is strikingly vibrant. The effect is further enhanced by working on a tinted paper, whose colour will help to unify the picture and enhance the effect of the vibrant pastel colours.

The Impressionists

This technique is used in both painting and drawing and is usually associated with the French Impressionist painters, who were the first to exploit its full potential in the late 19th century. The Impressionists were fascinated by the fleeting effects of light on the landscape and found that by building up their images with small flecks and dashes of colour they could capture visual sensations such as the glints of light on the surface of water or the dappled light beneath a tree. In addition, the many touches of colour added a shimmering quality to the picture surface, making it dance and vibrate with light.

Working methods

Pastels and coloured pencils are particularly suited to the

also best to keep the colours fairly close in tone, otherwise the vibrant effect of light is lost.

The aim of this technique is to achieve a sense of immediacy; the colours should be applied rapidly and confidently then left with no attempt made to blend them together. Always try to vary the size, shape and density of the marks you make, otherwise the effect will be monotonous. By altering the pressure on the pencil or crayon it is possible to make a range of stippled dots and broken flecks and dabs that give life and movement to the image.

Maureen Jordan

GIRL RESTING

Here, the artist blocked in the composition freely with watercolour washes and then reworked the image in pastel. This combination of translucent, fluid watercolour washes and grainy, broken pastel marks has a depth and subtlety that effectively conveys the transient effects of light and shade.

broken colour technique owing to their pure, vibrant hues and ease of manipulation. However. it is advisable to keep to a fairly limited range of colours to achieve an overall harmony rather than a discordant hotch-potch of colours. It is

DRAWING

Wild Flower Field

This charming view of a field in Spain was executed on the spot. To create the variety of dense foliage, grasses and flowers, the artist freely combined softly blended areas with linear marks, building a rich impression of colour and texture.

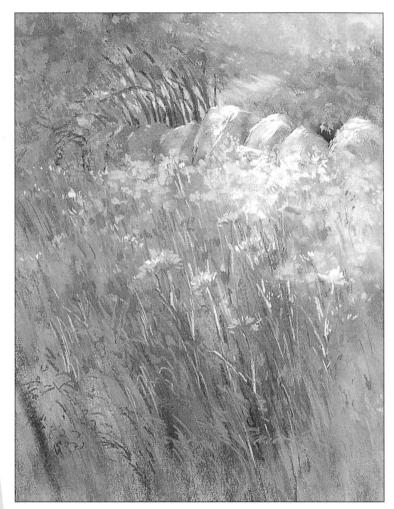

SOFT PASTELS IN THE FOLLOWING COLOURS

- Red-brown
- Ochre
- Blue-green
- Grey-purple
- Pale cobalt
- Blue
- Medium olive
- Green

- Lemon yellow
- Blue-grey
- Pale cream
- Golden yellow
- Mid brown
- Dark brown
- Purple
- Turquoise blue

- Light blue
- Red-grey
- Pale blue
- Orange-red
- Pale pink
- Purple-pink
- Pale lavender
- Yellow-green

BROKEN COLOU

Working on the smooth side of the paper, start by plotting the position of the drystone wall and the landscape beyond using a thin stick of charcoal. The blue-grey paper provides a useful mid-tone upon which to work out the lights and darks.

Block in the sky with a light tint of cobalt blue, and suggest the distant hills with grey-purple. Work into the foreground field with strokes of cool blue-green and warm olive green, layering and blending the colour to build up a rich and varied surface. Use long, sweeping strokes to suggest the upward growth of the grasses. Use the same colours to define clumps of foliage in the trees.

Rough in the main colour areas with broad side strokes. Use blue-green for the distant trees, then work across the foreground with red-browns and ochres. Add strokes of grey-purple on the wall. Blend the scribbled marks with a tissue. This creates a subtle underpainting that will underpin the marks laid over it.

RAWING

Lightly spray the drawing with fixative to seal the surface before the application of further colour layers. With short strokes of lemon yellow, touch in the field in the distance. Build up the shadows on the wall with short side strokes of purple, blue-grey and cobalt blue. Pick out the sunlit highlights on the wall with soft yellows, pinks and creams, then define the individual rocks with sketchy charcoal lines. Draw the tree trunks with warm and cool browns and purples, using the point of the pastel stick.

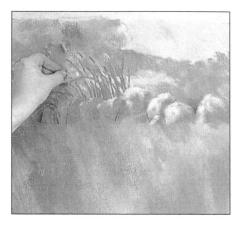

Suggest the cool, silvery areas of foliage with a mid-tone turquoise blue. Add strokes of this colour in the foreground field, too, creating colour echoes that help to unify the picture. Introduce lighter tones with strokes of pale cream, blending them

with your finger. In the detail of the foreground field (left) we see the vibrant effect created by the combination of blended and linear marks.

Work some pale cobalt blue into the foliage of the trees to open them up and suggest the sky peeping through. Stroke some golden yellow on to the rocks where the sunlight strikes them. Now start to build up linear detail over the blended marks in the foreground. Using cream, light blue, pale lavender and red-grey, and working with the tip of the pastel, make lively, expressive marks for the heads of the wild flowers. Long strokes of dark green, olive green, red-brown and ochre give a lush depth to the grasses.

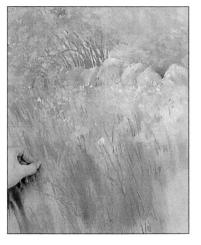

BROKEN COLOUR

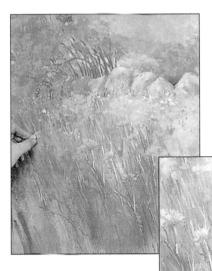

Use pale greens and creams to pick out the lighter grasses, and continue working on the flowers using the same colours as before. Add one or two brilliant yellow and orange-red flowers here and there –

apply solid dots of pastel, then press them into the paper to create touches of vivid, saturated colour. To give the picture depth, use bigger, more emphatic marks for the nearest flowers and smaller, softer marks for those further

> back. Define a clump of daisies in the foreground with strokes of pale pink and purple-pink, to create a point of focus. In this detail you can see how the forms of the daisies are conveyed using pale pink for the inner petals and purple-pink for the undersides.

8 Knock back the hills in the background with a little pale blue to convey a sense of distance. Build up the texture of the dark grasses in the foreground with short strokes, dashes and dots of turquoise blue, blue-green and ochre to suggest movement. Suggest the tangle of leaves and grasses with random dots and little circular scribbles. To emphasize the vibrant colours of the flowers, work flecks of blue-green in between them.

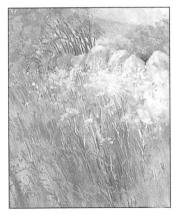

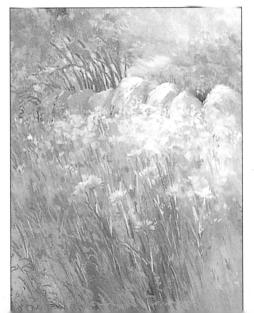

Add flecks of yellow-green to suggest the sunlit areas of foliage on the trees. Add touches of the same colour in the foreground grasses to unify the picture. Finally, add highlights to the rocks and flowers with touches of pale cream to give the picture added sparkle.

Helpful Hint

IF YOU MAKE A MISTAKE, BRUSH OFF THE POWDERY COLOUR WITH A FIRM-BRISTLED PAINTBRUSH. ALTERNATIVELY, USE A GENTLE DABBING MOTION WITH A KNEADED ERASER. RAWING

Conté Crayons

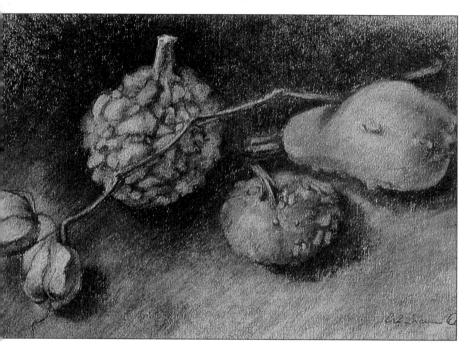

Cristiana Angelini GOURDS Conté crayons in traditional earth colours were used for this finely wrought still-life study. The artist has achieved subtle gradations of tone using closely hatched lines, allowing glimpses of the grey paper to serve as the highlights.

Conté comes from France and is named after its inventor, Nicolas-Jacques Conté. Conté crayons are similar to soft pastels, but slightly harder and oilier. They are made from compressed chalk and graphite bound together with gum and a little grease and formed into squaresectioned sticks. Conté is also available in pencil form.

Grades

Black and white conté crayons come in three different grades: HB (medium), B and 2B (the softest). All other colours are available in only one grade – approximately 2B. The softer the crayon, the more intense the mark it makes and the easier it is to blend.

Colours

Traditionally used for tonal drawings, conté crayons were in the past limited to black, white and three earth colours – sepia (a rich, reddish brown), sanguine (blood-red) and bistre (dark brown). Although conté is now available in a wide range of colours, many artists still favour the restrained harmony of the traditional colours, which bestows on a drawing a 'classical' look reminiscent of the beautiful chalk drawings of Leonardo da Vinci, Michelangelo and Rubens.

Papers

Conté crayons are used to best advantage on a grey, cream or buff tinted paper which provides

CONTE CRAYONS

a sympathetic background for the overlaid colours. Like pastel and charcoal, conté crayons require a paper with sufficient surface tooth for the powdery pigment to adhere to. When the textured grain of the paper is visible it becomes an integral part of the drawing, bringing out the distinctive qualities of the marks and adding an extra dimension to your work.

Techniques

As with pastels, the most practical method of using conté crayons is to snap off small pieces and use the sharp corners for linear marks and the side of the stick to block in tonal areas. Conté is also soft enough to allow colours and tones to be blended by rubbing with a finger, tissue or torchon (paper stump).

The technique known as drawing à trois crayons, (with three colours) in which sanguine, black and white conté are used together, was particularly popular in the 17th century and remains so today. Worked on grey or light brown paper, it allows tones to be translated easily and gives a rich feeling of tone and colour as well as form. The sanguine crayon is used for drawing outlines, toning and shading, with black and white used sparingly to pick out the darker tones and the highlights. You can also use hatching and crosshatching with white and sanguine together to get pink tones of various shades and intensities.

Cristiana Angelini

STILL LIFE WITH DRIED FRUIT Here, coloured conté crayons have been used to create a high-key drawing, in contrast to the low-key one opposite. The artist has, however, used a limited range of colours in order to preserve an overall harmony.

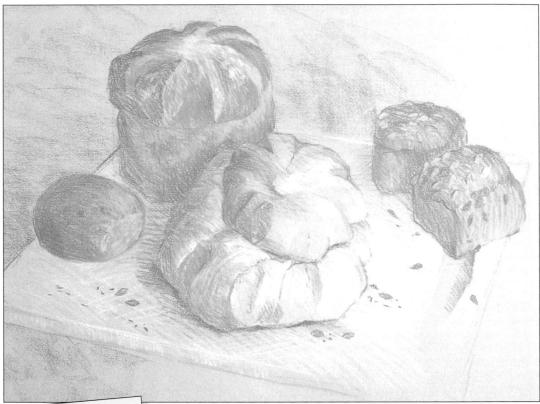

CONTÉ CRAYONS IN The following Colours

- Bistre (dark brown)
- Raw Sienna
- Gold Ochre
- White

Baker's Selection

The warm earthy tones of traditional conté crayons are perfect for capturing the golden crustiness of these freshly baked loaves. Conté crayons are shown to their best advantage on tinted paper, which gives a subtle extra dimension when incorporated into a composition. Here the grey paper provides the cool shadow tones and provides a foil for the warm earths and yellows.

CONTE CRAYON.

Start by lightly sketching the composition with the bistre crayon. Use a sharp corner of the square stick to make fine lines. You may find it useful to draw light horizontal and vertical lines to help you position the objects accurately on the paper. Exaggerate some of the angles to make the composition more interesting.

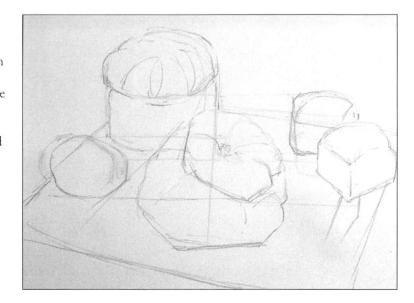

Helpful Hint KEEP THE HATCHING LOOSE AND OPEN IN THE EARLY STAGES; IF THE WORK IS DONE TOO DENSELY AT FIRST, IT BECOMES DIFFICULT TO BUILD UP THE COLOUR AND CONTROL THE TONES.

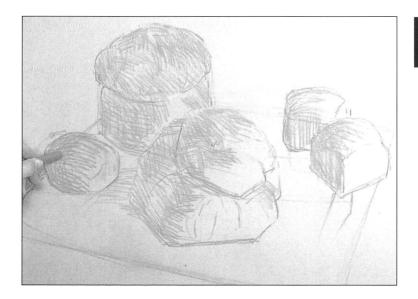

2 Switch to the raw sienna crayon and start to build up the colour of the bread and rolls with light crosshatched strokes. Change the direction of the strokes as you work, pivoting from the wrist, to emphasize the changes of plane. Leave areas of the paper untouched for the palest highlights.

DRAWING

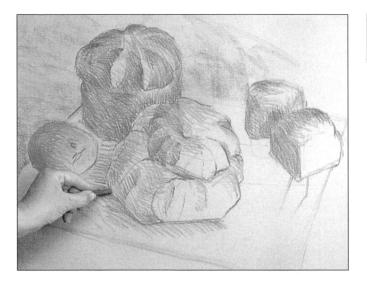

Work back over the drawing with the bistre crayon to define the

shapes more accurately. Use hatched and crosshatched strokes to build up depth of tone and establish the forms of the loaves, but still leaving plenty of the ground showing through. Indicate the cast shadows on the cutting board with rapid hatched strokes. Lightly shade in the background, using the side of a broken piece of crayon to lay in broad, scribbled strokes.

The directional light picks up the sharp contours of the crusty

loaves. Use the gold ochre crayon to hatch in these lightstruck areas, following the contours of the loaves to create an impression of form and solidity as well as texture. Concentrate more light on the cottage loaf at the front of the

group, so that it will stand out as the focal point of the finished drawing. The detail (right) reveals how, even at this midway stage, the strokes are kept loose, allowing for the brighter highlights to be added later in white conté.

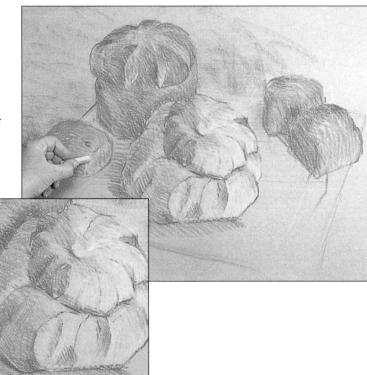

CONTE CRAYONS

Accentuate the lightest highlights, applying further layers of hatched and crosshatched strokes with the white conté crayon. Then use

the bistre crayon to re-define the shapes of the bread rolls. Suggest the sunflower seeds on the small rolls with a combination of bistre and gold ochre crayons.

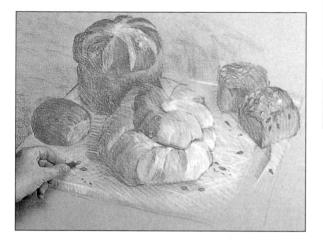

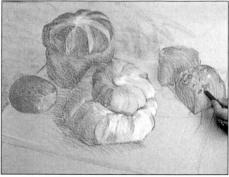

6 Work on the cutting board now, putting in the highlights with loosely hatched strokes of white conté. Draw the loose seeds on the board with the bistre crayon, adding gold ochre highlights.

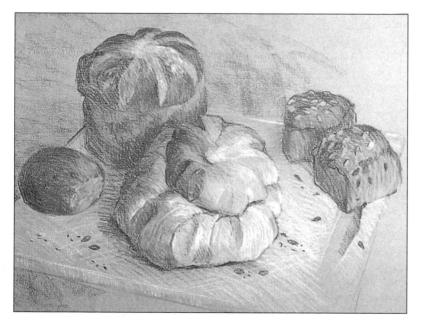

7

Using the bistre and gold ochre

crayons, work back over the drawing adjusting shapes and tones and adding dark accents and final light touches. Add a few dashes of white over the tops of the loaves and bread rolls to suggest a dusting of flour. Fix your drawing with a light spray of fixative to prevent smudging. RAWING

Blending

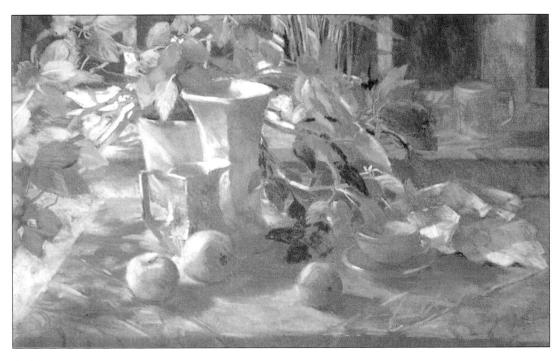

Jackie Simmonds EVENING LIGHT

Softly blended tones give a rich, painterly quality to this still-life drawing in pastel. The artist, however, uses minimal blending with her fingers as this can muddy the colours. Instead she uses the sides of the pastel sticks to float one colour over another, letting them blend naturally on the paper.

Soft, powdery media such as pastel, conté crayon, charcoal and soft pencil can be smudged and blended very easily to create a range of subtle textures and effects. In landscape drawing, for example, blended tones can be used to suggest the soft, amorphous nature of skies, water and soft foliage, and in recreating the effects of space, distance and atmosphere.

The technique has many other uses, for example in defining the form and volume of objects using smooth gradations from light to dark, softening linear marks and details, suggesting smooth surfaces, lightening tones, and tying shapes together.

Techniques

To create an area of blended tone, either apply lightly scribbled strokes with the point of the drawing implement, or use it on its side to make a broad mark. Do not apply too much pressure – if the mark is too ingrained it will be

BLENDING

difficult to blend it smoothly. Then lightly rub the surface with a fingertip to blend the marks and create an even tone. Repeat the process if a darker tone is required.

Similarly, two adjoining colours can be blended together where they meet to achieve a gradual colour transition, and two colours can be applied one over the other and then blended to create a solid third colour.

The finger is perhaps the most sensitive blending 'tool', but depending on the effect you want to achieve, you can use a rag, paper tissue, brush or torchon (a pencil-shaped tube of tightly rolled paper). Use your finger to blend and intensify an area of tone or colour; rags, tissues and brushes to blend large areas and to

soften and lift off colour; and a torchon for precise details.

Lively colour

Blending is a very seductive technique, but when overdone it can result in a rather slick. 'boneless' drawing. With pastels in particular, overblending can rob the colours of their freshness and bloom (this bloom is caused by light reflecting off the tiny granules of pigment clinging to the surface of the paper). You don't always have to rub or blend the colours; if you use the pastels on their sides you will find that the gradual overlaying of strokes causes them to merge where required without muddying. Always remember that a light, unblended application of one colour over another is more

vibrant and exciting than a flat area of colour.

As a rule of thumb, it is best to retain the textural qualities of the drawing as much as possible and to use blending in combination with other, more linear strokes for contrast.

Tiki Regwun FIGURE STUDY

Pastel and watercolour are a sympathetic combination. In this drawing the artist has matched the fluid, translucent quality of watercolour with the soft, powdery nature of pastel to create hazy 'pools' of colour that give depth and mystery to the image.

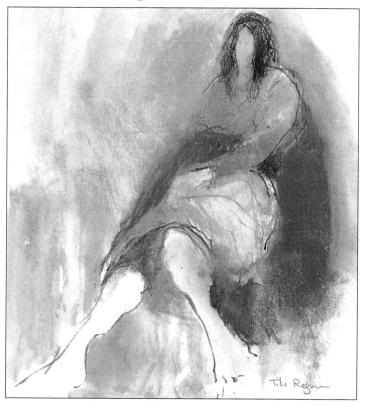

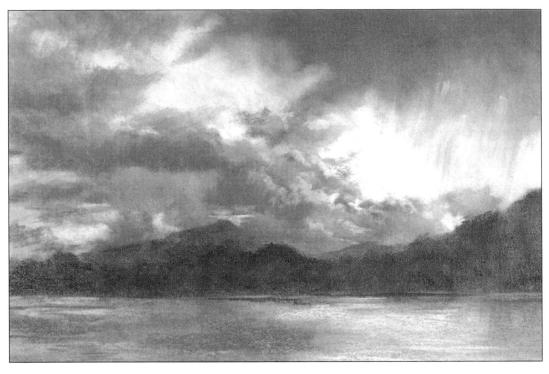

✓ Sheet of smooth grey pastel paper, 25½ x 19¾in (65 x 50cm)

✓ Fixative spray ✓ Soft tissues

Clouds and Rain

Soft pastels are ideal for capturing the fleeting effects of nature, and are well suited to outdoor work, thanks to their speed and readiness of handling. In this striking study of storm clouds the artist has built up the amorphous cloud shapes by blending the pastel strokes with her fingers and dragging with a crumpled tissue.

SOFT PASTELS IN THE FOLLOWING COLOURS

- Blue-purple
- Purple-grey
- Cobalt blue
- Mouse grey
- Salmon pink
- Yellow ochre
- Light yellow ochre
- Raw sienna
- Golden yellow
- Medium purple
- Light blue-purple
- Pale cream
- Light blue-grey
- Light beige

BLENDING

With skies it is best to avoid drawing any outlines, as you want to keep the image soft and loose. Snap off short pieces of pastel and use their sides to scribble down a range of appropriate colours for the sky and landscape. Use blue-purple, purple-grey and mouse grey for the rain clouds and landscape, and cobalt blue, pink, yellow ochre, raw sienna and golden yellow for the sky and the reflection in the water.

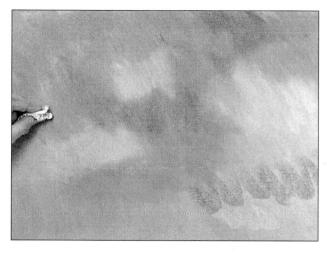

2 Use a crumpled tissue to soften and blend the pastel marks and intensify the colours. In effect, you are making a loose underpainting which will act as a guide for the colours you apply on top.

Block in the mountains with broad side strokes. using purple for the nearer range and purple-grey for the distant range. Blend the marks with your fingers and a crumpled tissue. Start to develop the rain clouds, working over the blended layer with side strokes of blue-grey and mouse grey. Use golden yellow and raw sienna for the lighter patches of sky, echoing the colours in the water. Use your fingers to soften and blur the clouds, dragging the colour downwards to create a sense of movement.

R A W I N G

Step back from your picture at intervals to assess the overall effect. Continue developing the cloudy sky using blended strokes of light blue-purple. Suggest weak sunlight breaking through on the right with strokes of light yellow ochre, again blending with your fingers. Use the same colour to lighten the reflection on the water, sweeping the colour lightly across the painting with broad strokes.

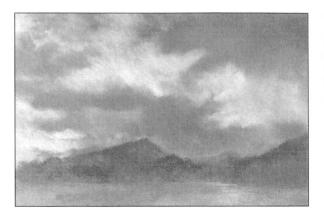

Helpful Hint A SMALL PLASTIC TRAY – THE KIND SUPERMARKET VEGETABLES COME IN – MAKES A LIGHTWEIGHT AND EASY-TO-HOLD 'PALETTE' IN WHICH TO KEEP THE PASTELS YOU ARE USING FOR A PARTICULAR DRAWING.

Introduce just a hint of pink into the sky on the left,

then use a pale cream to emphasize the lighter clouds. Stroke a light bluegrey onto the light-struck tops of the clouds. Touch in some smaller clouds near to the horizon with the same colour, to help create the illusion of receding space. Blend the lower

part of each stroke down into the darker clouds beneath. This detail reveals the variety of subtle marks used in the clouds. Soft vaporous rain clouds are suggested with blended strokes, while the broken tops of the cumulus clouds near the horizon are created with small scumbled strokes.

BLENDING

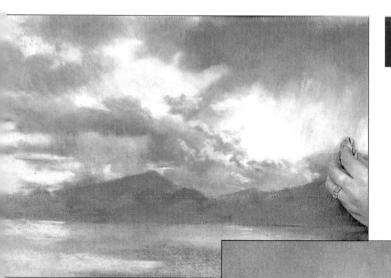

Use sweeping side strokes of blue-grev over the water and. where the weak sunshine is

reflected on the left, just a hint of light vellow ochre. Make your strokes wider apart as you move towards the front of the picture. Touch in some loose strokes of mouse-grey to suggest the trees on the nearer mountains. Lightly scumble with a pale cream pastel to

> suggest feathery fragments of light cloud scudding across the sky. Add touches of light beige above the area of pale cloud on the right, then lightly drag the colour down with a tissue to give a suggestion of mist and rain (see detail left).

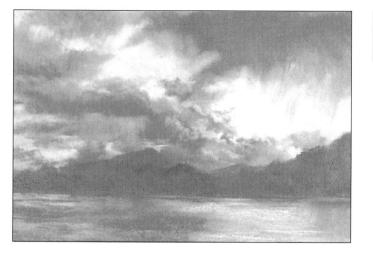

To complete the picture, work over the nearer hills with soft

greens and purples to give them a little more definition. Feather some strokes of pale blue-grey over the distant mountains, which are partly obscured by cloud. Add the highlights on the water's surface with strokes of pale blue and pale cream.

67

Line and Wash

AWING

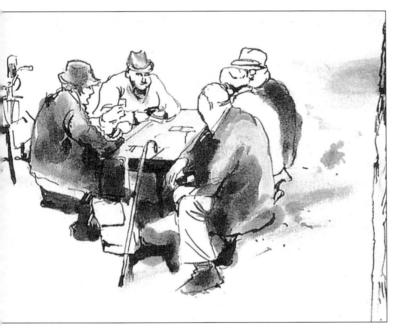

Philip Wildman CARD PLAYERS

The essence of a good line-and-wash drawing is brevity; the secret is knowing how much to put in and how much to leave out, so that the viewer's own imagination comes into play. Rapidly executed on site, this monochrome line-and-wash drawing conveys a lot of information with great economy of means.

Line and wash is an extremely expressive and attractive technique in which finely drawn lines and soft, fluid washes work together in perfect harmony. The lines – produced with pencil or pen – give structure and lively emphasis to the drawing, while diluted washes of ink or watercolour suggest form, movement and light. The inherent fluidity of the line and wash technique makes it ideal for portraying living, moving subjects such as figures, animals and flowers. Landscape artists, in particular, find it an invaluable method of making rapid sketches of the fleeting effects of light, or the movement of clouds.

Some of Rembrandt's most beautiful drawings were executed using the line and wash technique. With just a few brief pen lines and curving sweeps with an ink-loaded brush, he was able to capture the play of light on a figure with exquisite simplicity.

Techniques

The traditional method is to start with a pen drawing, leave it to dry and then lay in light, fluid washes of ink or watercolour on top. These washes may be either monochrome or coloured. When the first washes are dry, further washes are added to build up the dark and mid tones, leaving areas of bare paper to serve as the highlights. Alternatively, washes can be applied first to establish the main tones, with the ink lines drawn on top. Some artists prefer to develop both lines and washes at the same time.

The attraction of a line-and-wash drawing lies in its sketchy, 'unfinished' quality, suggesting more than is actually revealed. Thus the viewer is able to participate in the image by using his or her imagination to fill in the details. Never

LINE AND WASH

overwork a line and wash drawing -a few scribbled marks and simple, broad washes are all that is necessary to convey what you want to say.

Pens

The type of pen you choose to draw with will depend on the effect you are aiming for. It is worth experimenting with a range of different pens and brushes to discover which ones are best suited to your style of drawing. Dip pens, quill pens and reed pens, for example, produce very expressive lines that swell and taper according to the amount of pressure applied with the nib. These are ideal for making bold, spontaneous marks. In contrast, modern technical pens have very fine nibs that produce thin, spidery lines of even thickness and are suited to a more controlled, graphic style of drawing.

Brushes

Watercolour brushes can be used for lines and for washes. Don't use too small a brush as it encourages tight, hesitant marks. With a large, good-quality brush you can make sweeping washes, and it will come to a point for painting details.

Inks

It is important to choose the right type of ink for drawing the lines. If you want to overlay washes without dissolving the drawn lines, choose Indian ink, which is waterproof. If you want to be able to dissolve and blend some of the lines, choose a soluble ink instead.

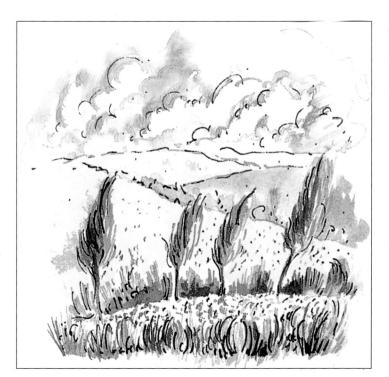

Anna Wood

TUSCAN LANDSCAPE Based on imagination and memory, this lively drawing conveys a marvellous sense of light and movement. The artist worked intuitively, blocking in the sky and landscape rapidly with loose washes of coloured ink, leaving flecks of white paper to add sparkle. Then she emphasized the rhythms of the clouds, trees and grasses with a few dancing pen lines.

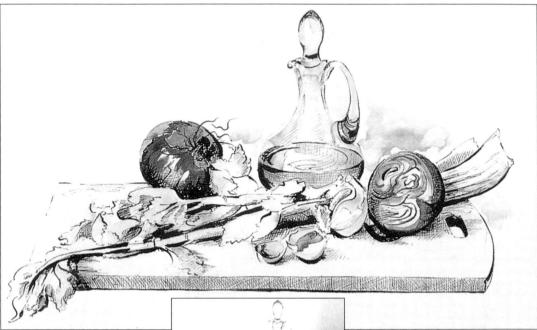

WING

YOU WILL NEED

- ✓ Sheet of 90lb (190gsm) Not surface watercolour paper 15 x 22in (38 x 56cm)
- Black and brown waterproof drawing inks
- ✓ Dip pen ✓ HB pencil ✓ Eraser
- ✓ No. 2 round watercolour brush

Red Onions

A simple composition of fresh vegetables is the subject of this line-and-wash drawing. First, the main outlines and shading were drawn with a dip pen and ink. Then watercolour washes were applied in a free and spirited style. This combination of

WATERCOLOUR PAINTS IN THE FOLLOWING COLOURS

- French ultramarine
- Cadmium yellow
- Cadmium red
- Cyanine blue
- Burnt sienna
- Lemon yellow
- Sap green
- Permanent rose

crisp lines and fluid washes results in a drawing that is fresh and lively.

LINE AND WASH

Using an HB pencil, lightly draw the outline of the still-life main group.

Helpful Hint PRACTISE USING THE PEN ON A SCRAP OF PAPER UNTIL YOU FEEL COMPLETELY CONFIDENT THAT YOU CAN DRAW A STEADY LINE. GRIP THE PEN QUITE LOOSELY SO YOU CAN DRAW EXPRESSIVE, FLOWING LINES.

Beepen the tone of the darker shadows on the vegetables, adding horizontal and vertical crosshatched lines on top of the angled ones. In this close-up detail you can see the flowing, expressive lines produced by varying the angle of the pen nib and the degree of pressure applied. With practice you will be able to make a single line taper from thick to thin, without lifting your pen from the paper.

2 Mix up some black waterproof drawing ink in a container and add a little brown ink to soften the colour. Go over the pencil outlines with a dip pen and ink. Make loose, flowing lines and vary the pressure on the nib to create lines of varying thickness. Notice how the artist uses heavy lines in the shadow areas and thin, tapering lines for the light-struck areas. To darken areas and introduce tones go over the lines again to make them thicker. Some areas can be completely shaded in, but don't add too much detail or the effect will be overwhelming.

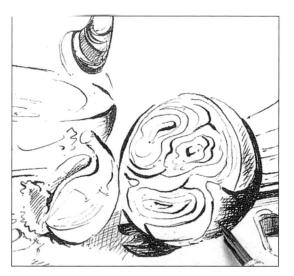

DRAWING

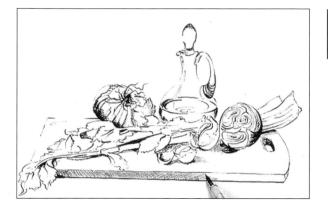

Suggest the shadows on the chopping board, and the shadows cast by the vegetables, using a network of lines that criss-cross each other diagonally. Again, work quickly and freely – if you are too precise the effect becomes stiff and mechanical.

5 Continue building up texture and tone throughout the drawing using hatched and crosshatched lines. Step back from time to time, to make sure you are not adding too much detail. When you have finished, leave your drawing to dry and then carefully rub out the pencil lines.

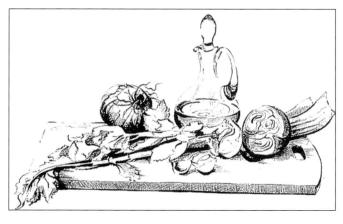

Now you are ready to apply watercolour washes over your drawing. First, mix burnt sienna with a little cadmium yellow and

dilute it to a very pale tint with lots of water. Apply this to the chopping board with a no. 2 round brush. Paint the red onion with a mix of French ultramarine, permanent rose and a touch of cadmium red. Leaving areas of the paper bare for the brightest highlights, first apply a diluted wash over the onion, then add a heavier, darker wash for the shadow areas. This use of light and dark tones gives the effect of the rounded form of the onion. Paint the celery with pale washes of sap green and lemon yellow.

LINE AND WASH

Paint the glass bottle with a

very pale grey mixed from cyanine blue and a little cadmium red. Brush this on loosely, leaving bare paper for the brightest highlights and reflections on the glass. Now paint the markings on the cut onion, using a mix of French ultramarine and permanent rose. Add a little cadmium red to the mix for the dark outer skin.

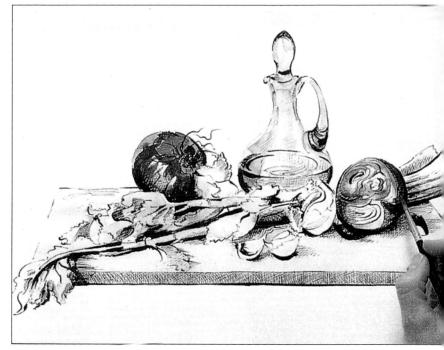

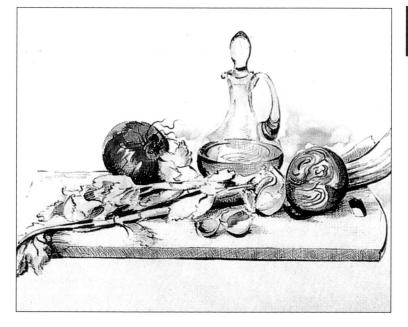

Using various mixtures of permanent rose, cadmium red and cadmium yellow, paint the delicate pinkish tones on the skin of the garlic cloves. Add a little ultramarine for the darker areas. For the oil in the bottle, mix lemon yellow, cadmium yellow and a little cadmium red. Finally, add a suggestion of shadow in the background, using a heavily diluted mix of cyanine blue with a little cadmium red.

RAWING

Pastel Pencils

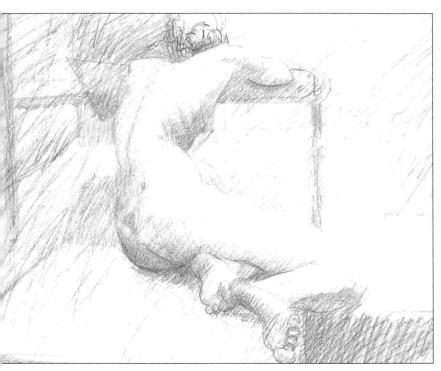

Sarah Donaldson NUDE STUDY Pastel pencils produce a translucent effect that is particularly suited to figure studies and portraits. Here the artist has built up the subtle hues in the skin by hatching and scribbling with a range of reds, yellows, blues and greens.

Pastels are available encased in wood, like conventional pencils, as well as in the more familiar stick form. Pastel pencils are a sort of hybrid of pastel and coloured pencil, combining many of the advantages of both.

Before committing yourself to buying a whole set of pastel pencils, it is worth testing out different brands until you find the one that best suits your drawing style. As with soft pastels, the consistency and 'feel' of pastel pencils varies from brand to brand; some are slightly harder and greasier than soft pastels, others have a line which is delicate, dry and dusty, like that of charcoal.

Pastel pencils come in a wide range of

colours and are convenient to use. Apart from the advantage of keeping your fingers clean, they are also less liable than stick pastels to crumble under pressure, so that you can obtain definite marks or lines, particularly with the point sharpened.

Techniques

Many of the techniques that are used with pastel sticks are suitable for pastel pencils. The difference lies in the greater degree of control a pointed tip gives you. Because you can hone the point to any shape – blunt, fine or chiselled – pastel pencils are ideal for subjects that entail intricate work, such as flowers and architectural PASTEL PENCILS

subjects. You can also make use of the linear qualities of pastel pencils to add crisp finishing touches to a soft-pastel drawing.

There are many different ways of 'mixing' colours on the paper surface. By using the hatching technique of laying a series of roughly parallel lines in different colours or tones you will achieve an optical mixing effect which is more vibrant than a flat area of colour. From a normal viewing distance the lines merge to give an impression of continuous tone or colour, but close up the individual marks can be deciphered.

You can also lay one set of hatched lines over another to create complex colour effects. This technique is known as crosshatching.

Alternatively, you can create smooth tones and colours by using the side of the point to build up thin layers of colour one over the other. Don't press too hard or you'll damage the paper surface and it will acquire an shaft, moving it backwards and forwards with a natural, sweeping movement and letting your wrist do the work.

Pastel and wash

Pastel pencils are water soluble, which means you can create a wash effect simply by 'painting' over the pastel marks with clean water and a soft brush. This technique can be useful for creating an 'underpainting' which, once dry, can then be worked over with further layers of dry colour.

Barry Freeman WINTER LANDSCAPE The artist used a combination of pastel pencils and oil pastels for this sketch, which he later used as the basis for an oil painting.

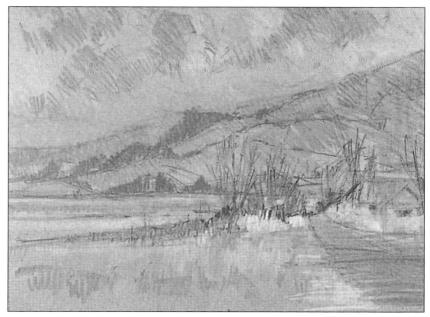

unpleasant sheen. The colours can be deepened and enriched by blending with your fingertip, or you can use a torchon (paper stump) for fine details.

The way you hold your pencil has a considerable effect on the marks you make. Grasp the pencil close to the point for detailed work. For broader areas of colour, hold the pencil loosely and further up the

RAWING

By the Sea Shore

Pastel pencils, combining the painterly qualities of pastel sticks and the linear qualities of coloured pencils, are excellent for rendering natural subjects such as these sea shells. The pale, bleached colours, reminiscent of bright sunlight on a hot day by the sea, are achieved by overlaying one colour over another with small, delicate strokes.

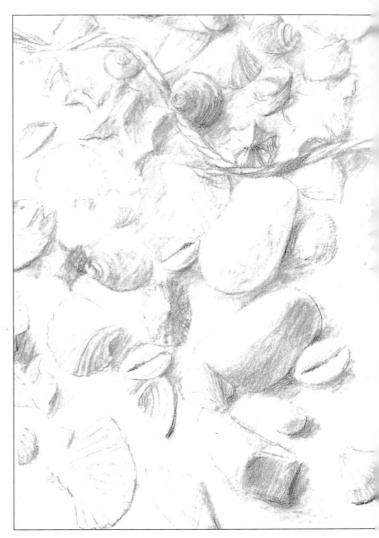

PASTEL PENCILS IN THE FOLLOWING COLOURS

- Pink beige
- Naples yellow
- Cadmium yellow
- Turquoise
- Orange
- Light purple

- Violet
- Dark green
- Dark blue
- Raw sienna
- Dark purple
- Black

76

First set out your composition, using an HB pencil to lightly draw the shapes of the shells and the piece of string. When you are happy with your sketch, carefully

knock back some of the harder lines by lightly crosshatching over them with the corner of a plastic eraser to leave a faint, subtle outline. Using a soft pink-beige pastel pencil, draw over the lines of the shells as shown

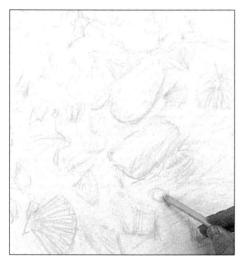

Helpful Hint

WITH A COLOURFUL SUBJECT LIKE THIS ONE, START BY BLOCKING IN THE BROAD COLOUR AREAS OF THE COMPOSITION WITH THIN PAINT. THIS GIVES YOU A KEY AGAINST WHICH TO JUDGE SUBSEQUENT TONES AND COLOURS AND TAKES AWAY THE GLARING WHITE OF THE CANVAS.

Start to build up form and volume on the shells and string by gently crosshatching over the shadowy areas with a turquoise pencil. Press - but don't rub - a piece of crumpled kitchen

paper on to the surface to lift off excess pastel pigment. This prevents the tooth of the paper becoming clogged, allowing you to add further layers of colour.

Start building up the colour with Naples yellow. Work over the pink-beige outlines, defining the shapes of the shells and filling in some of the shadow areas. Use light, feathery strokes and a gentle pressure on the pencil. Shade the shells with softly hatched strokes, leaving plenty of white paper showing through. Switch to cadmium yellow to define the whorls and grooves on the shells and the lines on the string.

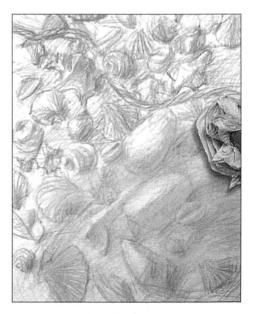

Use an orange pencil to emphasize the texture and strengthen the detail on the shells. With stronger, more deliberate strokes, start to build up the shadow areas by crosshatching over the turquoise lines with light purple, still allowing plenty of white paper to

RAWING

show through and give translucence to the colours. Use your finger to soften any pencil strokes that appear too strong. In this detail you can see how crosshatching with different colours produces an illusion of colour mixing where the lines cross. For example, strokes of light purple and turquoise combine to create touches of violet across the picture.

By using several layers of light colour instead of applying one dense layer, the fragile, ephemeral nature of the shells is captured.

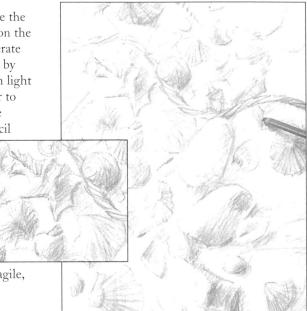

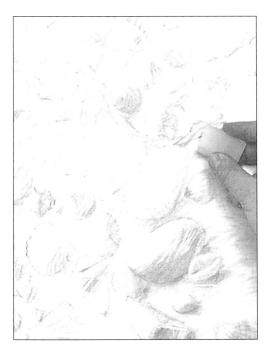

Helpful Hint

SHARPEN YOUR PASTEL PENCILS FREQUENTLY TO MAINTAIN A TRUE POINT AND KEEP THE IMAGE SHARP AND CLEAR. THE BEST WAY TO SHARPEN THEM IS WITH A CRAFT KNIFE. PENCIL SHARPENERS TEND TO BREAK THE PENCIL LEAD.

5 Knock back any excess colour by pressing gently with a piece of crumpled kitchen paper. This prevents too great a build-up of pigment and ensures that the strokes of colour remain vibrant and do not become muddy. With the point of a violet pencil, begin to define the shadows in the grooves on the surface of the shells, and deepen the cast shadows between the shells. To suggest one or two bright highlights on the shells and sand, use the corner of a plastic eraser to work across your drawing, removing areas of colour with short vertical strokes. PASTEL PENCIIS

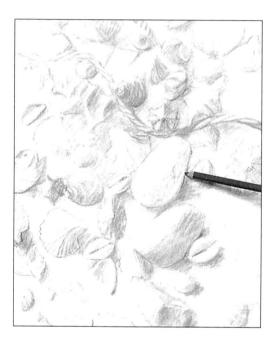

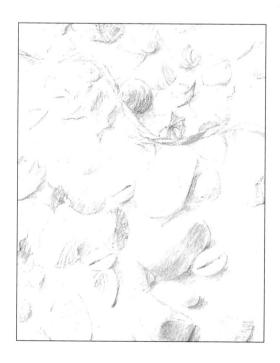

To convey the subtle variations of colour and texture within the shells, select pastel pencils in the colours that most closely match those of the individual shells. A dark green pencil is used to bring out the green areas in the shells, while strokes of dark blue and dark purple reinforce the stronger shadows. Work the colours into the background as well, letting the white of the paper show through and breathe air into the drawing. Create the lighter shadows with long strokes of light blue to offset the warm vellow tones most dominant in the shells. Define the grooves on the surface of each shell with raw sienna to enhance detail

Pick out the edges of the shells and the grooves over their surfaces with single strokes of blue, purple and raw sienna. The marks vou make should follow the lines of the shells, thereby describing the individual forms

To finish, work a little turquoise into the shadows and, with fine black lines, strengthen some of the edges of the shells in the foreground to bring them forward in the picture plane. Stand back and assess your picture; ensure that you have achieved a fine balance of warm and cool hues that describe the form and contour of the shells. Once you are satisfied with the result, spray the whole drawing with fixative to prevent smudging.

AWING

Charcoal and Chalk

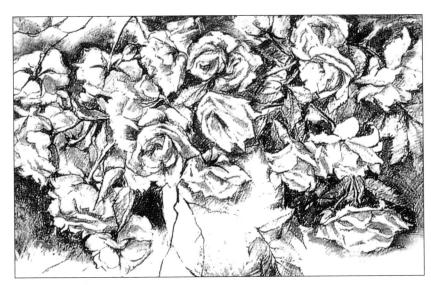

Cristiana Angelini WHITE ROSES This drawing proves that charcoal is capable of producing fine and delicate effects as well as bold ones. The artist worked on white paper, which serves as the highlights on the rose petals. Note the sensitive use of contrasting blended and unblended marks.

Charcoal as a drawing medium has a long and impressive history stretching back to the beginnings of art itself. It is a uniquely expressive medium with a delightful 'feel' to it as it glides across the paper. With only a slight variation in pressure on the stick you can produce a whole range of tones, from deep blacks to misty greys. The sharp corner of a broken piece of charcoal will produce strong and vigorous lines, while the side of the stick can be used to lay in broad tones. The soft, crumbly quality of charcoal makes the strokes easy to blend with your fingertip or with a paper stump, and highlights can be picked out with a putty eraser or a small pellet of kneaded white bread.

Tonal Drawings

The powdery quality of white chalk combines well with the dry, grainy nature of charcoal

lines. Together they cover the entire range of tone; the charcoal can be used heavily to represent deep black, and the chalk similarly for the highlights. A range of subtle intermediate tones is produced by using lighter pressure, or by blending the charcoal and chalk together.

A light grey paper with a textured surface is the best choice for drawings in charcoal and chalk, making it easier to judge the light and dark tones against the mid-tone of the paper. Canson and Ingres papers come in a range of colours and have a matt, softly textured surface suitable for the medium.

The soft nature of charcoal and chalk makes them prone to accidental smudging. It is advisable to rest the heel of your working hand on a sheet of scrap paper laid over the drawing, and to wipe your fingertips regularly with a damp cloth. Always spray the completed drawing with fixative.

CHARCOAL AND CHALK

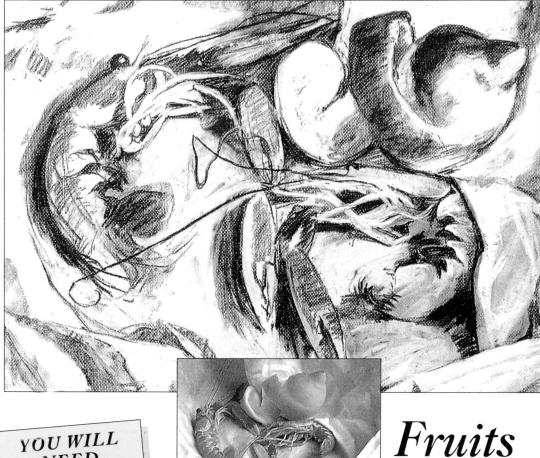

NEED

✓ Sheet of grey Ingres drawing paper, 213/4 x 16in $(55 \times 41 cm)$

✔ Thin and medium sticks of charcoal ✔ White chalk

✓ Kneaded eraser

Charcoal and chalk are so immediate and responsive in use, they are almost an extension of the artist's fingers. In this lively still-life study, charcoal lines define the contours of the forms while smudges and blended tones describe volume and texture. The grey paper provides an effective mid-tone, while white chalk is used for the highlights.

de Mer

AWING

Using a thin stick of charcoal, loosely sketch the main outlines of the still life, keeping your lines light but varied in strength and thickness.

Indicate the shadows on the lemon peel and in the folds of the waxed paper by drawing a dense charcoal line, then blending and fading it outwards with your fingertip.

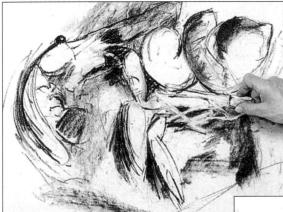

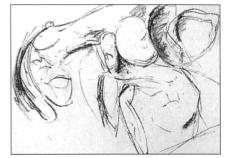

Use the thicker piece of charcoal to define the forms with firmer strokes. Blend with your fingertip to create rich, velvety dark tones. Snap off a small piece of charcoal and use the side to put in the mid-tones with light, scribbled strokes. Don't worry about detail at this stage but concentrate on

clarifying the shapes and proportions of the langoustines and the peeled lemon. To pick out the delicate light shapes of the langoustines' legs, use the corner of a kneaded eraser to 'draw' into the charcoal (see detail left).

Helpful Hint LIGHT LINES DRAWN WITH CHARCOAL ARE EASY TO CORRECT. IF YOU MAKE A MISTAKE, SIMPLY **RUB THE LINES WITH A PUTTY RUBBER OR A PIECE OF BREAD KNEADED BETWEEN YOUR** FINGERS AND THEN RE-DRAW

Continue working around the drawing, combining line with solid tones and re-defining the outlines of the subject as the work progresses. Don't finish one area at a time, but bring on all of the picture at the same rate. Build up the dark shadows on the lemon by skimming the charcoal across the paper and blending the strokes with your fingertips. Use a thin stick of charcoal to define the contours of the langoustines, using thick strokes to define the body and fainter strokes for the shadow areas.

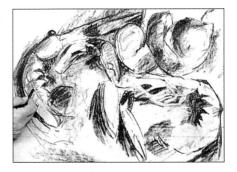

CHARCOAL AND CHALK

Now that your composition is beginning to take shape you can start working on the details. Put in more of the creases and folds in the waxed paper using the tip and side of a small piece of charcoal. Use the eraser to 'draw' the soft highlights on the paper and on the langoustines. Draw the langoustines' feelers using the sharp tip of a freshly broken charcoal stick, then strengthen the contours and the darkest areas of shadow.

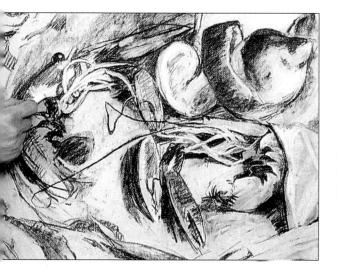

Helpful Hint CHARCOAL IS FRAGILE AND SHAPS WHEN APPLIED WITH PRESSURE. YOU MAY FIND IT EASIER TO DRAW WITH A SHORT PIECE OF CHARCOAL THAN WITH A WHOLE STICK.

5 Now use a stick of white chalk to pick out the sharpest, brightest highlights on the langoustines, the lemon peel and the creases in the waxed paper. Vary the directions of the strokes, following the shapes made by the folds in the paper.

To finish, work back over the drawing adding in final touches of 'colour' with both chalk and

charcoal, picking out the highlights and strengthening the contrasts. Spray your drawing with one or two light coats of fixative to prevent smudging.

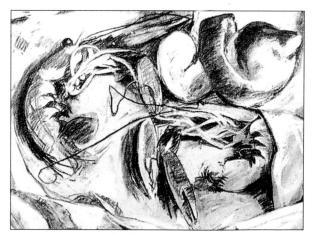

AWING

Frottage

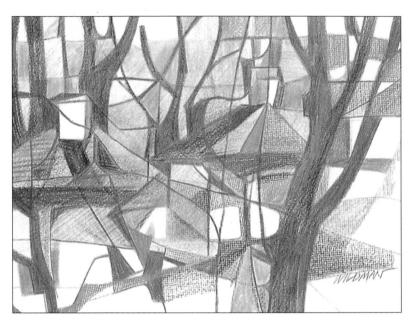

Philip Wildman TREE STUDY A group of houses and trees is here represented as a two-dimensional pattern resembling a stained glass window. Textural interest is provided by the use of frottage in different parts of the drawing; the paper was laid over the reverse side of a piece of hardboard and gently rubbed with coloured pencil.

This is a method of suggesting patterns or textures in a drawing by placing a sheet of paper over a surface with a pronounced texture, such as grainy wood or rough stone, and rubbing with a soft pencil, charcoal or pastel so that the texture comes through. The word 'frottage' is derived from the French word frotter, meaning to rub.

The most obvious use for frottage is in depicting a specific texture such as rock, stone or wood, and it is most often combined with freehand drawing. Frottage is also useful when you want a subtle but interesting pattern to enliven a broad area such as an empty foreground. You can also use it creatively by taking a rubbing from one object and using it in an entirely different context. You could, for example, use rubbings of leaves to represent trees in a landscape. During the early 20th century the German surrealist painter Max Ernst used frottage in this way, often combining frottage with collage to create strange, haunting images.

The patterns and effects achieved with frottage vary widely, as they are affected by both the thickness of the paper and the implement used for making the rubbing. Experiment with the technique, taking impressions from surfaces such as heavy sandpaper, coarse woodgrain, paper doilies or textured fabrics such as hessian and canvas. Interesting broken-colour effects can be obtained by making a rubbing with, say, a blue pastel, then moving the paper slightly and rubbing again with a yellow pastel to create a lively greenish hue.

FROTTAGE

YOU WILL NEED

✓ Sheet of heavy card, 30 x 20in (76 x 51cm)

 Sheets of coloured tissue paper: Dark green Bright green Dark blue Yellow Light orange Dark orange Brown

✓ Pineapple
 ✓ Orange
 ✓ Lemon

- ✓ Nutmeg grater
- ✓ Can of spray mount

Citrus Fruits

Whatever your level of experience, trying out new techniques and materials will broaden your range of expression. This vibrant still life was constructed from a collage of pieces of coloured tissue paper. These were then worked over with

OIL PASTELS IN THE FOLLOWING COLOURS

- Purple
- Orange
- Light green
- Dark green
- Yellow
- Dark brown
- Reddish brown
- Olive green
- Deep aquamarine

oil pastels, using the frottage technique to suggest the various textures of the fruits. AWING

Start by making the individual collage elements from tissue paper, using the frottage technique. Firmly press a sheet of dark green tissue paper over the pineapple and gently rub over the surface with the side of a purple oil pastel. Highlight with orange, light green and dark green oil pastels to build up the characteristic colours of the fruit. Repeat with dark blue tissue paper for the second pineapple, frottaging with orange and light green pastels.

Prepare six orange cutouts in the same way, using light and dark shades of orange tissue paper. Frottage with purple and dark brown

pastels for the shadows on the oranges, and yellow for the highlights.

Now prepare three lemon-shaped cut-outs. Lay a sheet of yellow tissue paper over a nutmeg grater and draw the outline of a lemon on it, roughly life-size, using the side of a vellow pastel. Add shading with light green pastel, leaving some parts of the tissue paper untouched. Lay the tissue paper sheets aside for now.

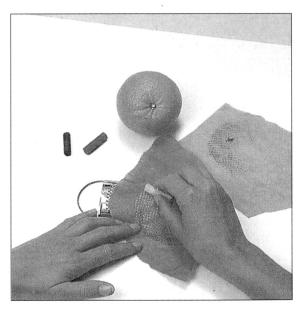

FROTTAGE

Remove a large and a small leaf from the pineapple. These will be used to frottage the whole crown of leaves. Lay a sheet of dark blue tissue paper over a leaf and gently frottage with a light green pastel to create an outline of the leaf. Repeat using both leaves, moving the paper slightly each time to create a fan of overlapping leaves. Use more colours – olive green, reddish brown and deep aquamarine – to add interest and suggest threedimensional form. Repeat this process for the crown of the second pineapple.

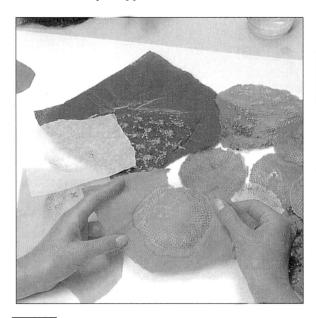

6 Now you can assemble your collage picture. Cover the entire backing board with a sheet of bright green tissue paper, attached with spray mount. Tear a piece of light orange tissue paper to represent the wooden chopping board. Start arranging the fruit shapes on the surface, with some overlapping others. When you are happy with the composition, fix the shapes in position with spray mount.

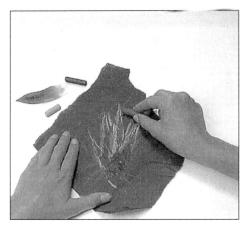

5 When you have finished frottaging the textures of the fruits, tear out the shapes ready to be assembled as a collage. If you cut the shapes with scissors they will appear unnatural and hard cdged; to create softedged shapes, lay each sheet of tissue over its corresponding fruit, dampen the paper around the edge of the fruit shape and then carefully tear it out.

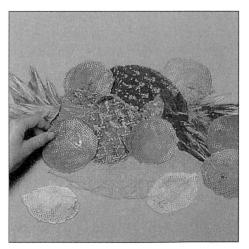

WING

Continue sticking the shapes in place, adding torn strips of brown tissue for the shadows under the lemons and vellow tissue for the

highlight on the chopping board. Use torn pieces of dark green tissue for the shadows cast by the arrangement on the green cloth. These shadows help to anchor the group to the table and also add colour and shape interest.

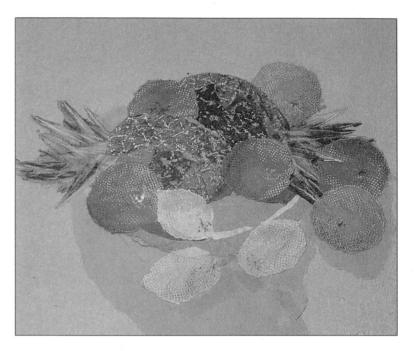

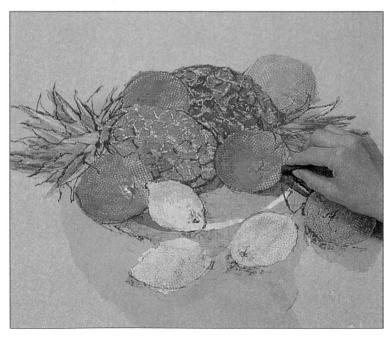

Using the purple oil pastel, draw around the edges of the fruits with broken lines to add definition and emphasize the

shapes. Pick out some of the individual pineapple leaves, and darken the shadows immediately beneath the fruits.

CROSSHATCHING

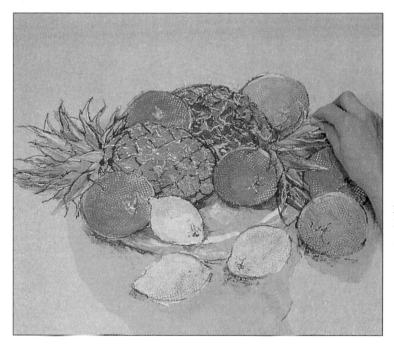

9 Switch to the orange pastel and add bright highlights to the tops of the fruits and the edges of the pineapple leaves.

Helpful Hint TISSUE PAPER TEARS

TISSUE PAPER TEARS EASILY, SO WHEN GLUING HOLD THE SHAPE FIRMLY AND APPLY THE GLUE FROM THE CENTRE OUTWARDS.

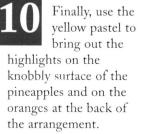

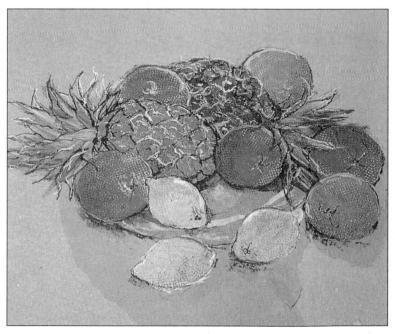

RAWING

Graphite Sticks

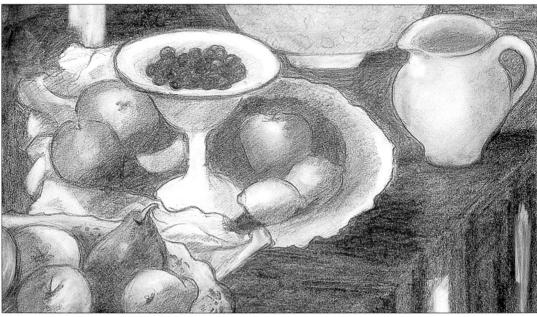

Gail Reagan STILL LIFE STUDY This tonal sketch was done in preparation for a painting in oils. The artist used graphite sticks, which have smooth, free-flowing properties and can be blended to produce a varied range of tones.

Graphite sticks come in grades ranging from hard to soft and in two different types – round pencils and hexagonal sticks which are good for making broad sweeps. A graphite stick looks like a very thick drawing pencil, but pick one up and you'll find that it is much heavier. This is because it is made from compressed graphite.

Graphite sticks are a very tactile medium. The silky feel of the lead, which is dark and soft, is very pleasing and the chunkiness and weight of the stick in your hand has a liberating effect – it makes you want to make big, bold, spontaneous drawings. For this reason, graphite sticks are to be recommended to beginners because they encourage you to think about the whole subject in broad terms and not become lost in too much meticulous detail.

Graphite sticks glide smoothly across the surface of the paper, enabling you to make expressive lines and block in solid areas with ease. Light pressure on the stick will give soft, silvery marks that allow the texture of the paper to show through. Heavy pressure yields rich, intense tones. The marks can be varied by using the point, the side of the pointed end, or the flattened length of the stick. Graphite sticks also lend themselves beautifully to smudging and blending techniques.

GRAPHITE STICKS

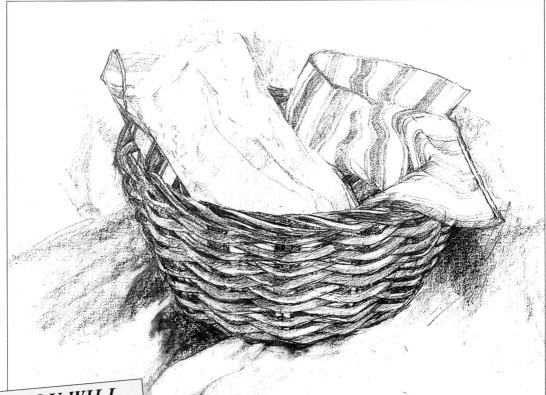

YOU WILL NEED

✓ Sheet of good quality cartridge paper, 16H x 13Gin (42 x 34cm)

 ✓ 4B and 6B round graphite sticks
 ✓ Kneaded eraser
 ✓ Fixative spray

A Study in Textures

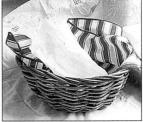

Often the best still-life subjects are found rather than contrived. This basket of assorted papers and cloths presents a

range of textures and tonal variations which the artist has exploited to great effect. Graphite sticks are a joy to work with, producing expressive, linear marks and rich, softly graded tones with a silky sheen.

91

RAWING

Fix the paper to the drawing board with pins or tape. Lightly sketch in the whole image with the 6B graphite stick, ensuring that your composition fills the page.

Work freely from your elbow, using the side of the stick to block in the broad areas of shadow. Keep the drawing loose and sketchy to allow for re-drawing as the image develops.

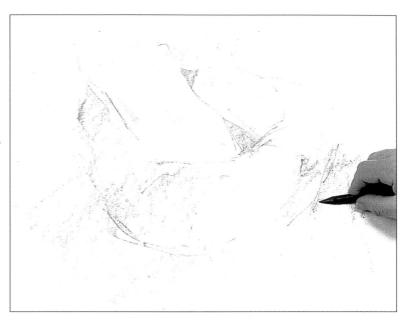

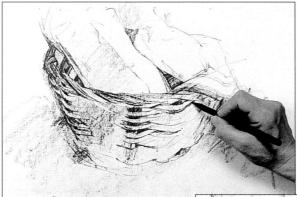

Now you can begin to firm up the drawing, referring frequently to your subject to check that the shapes and proportions are correct. Start working on the weave of the wicker basket, this time using the point of the 4B stick to make stronger lines. Notice how the weave gradually becomes darker as the basket curves back in space. Use the sharp corner of an eraser to lift out small areas of light striking the weave

Helpful Hint CORRECT MISTAKES BY **RESTATING AN INCORRECT** LINE RATHER THAN RUBBING IT OUT AND STARTING AGAIN. THESE EXPLORATORY LINES AND MARKS GIVE EXTRA RHYTHM TO YOUR DRAWING.

(see detail). Because the wicker work is quite a complicated design, you need to simplify it. Look closely at the basket for its broad forms. Keeping the drawing quite light at this stage, loosely indicate some vertical canes first, then add the horizontal wickers which curve over them.

GRAPHITE STICKS

3 Continue building up the basket weave, using the point of the pencil to draw the canes and the edge for shading. Keep in mind the play of light and shade on the basket and use lighter and heavier lines to indicate the relative tones and shadows. Define the twisted rim of the basket, smudging some of the lines to suggest shadows and highlights. Use the side of the softer 6B stick to darken the cast shadow under the basket to give it weight and solidity.

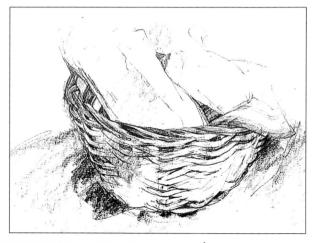

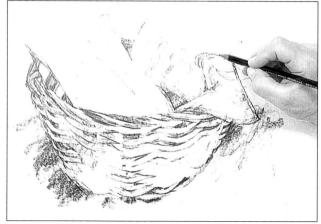

4 Use the point of the 4B stick to draw the striped pattern on the napkin, carefully following the contours of the creases and folds in the fabric. Fill in the stripes with layers of finely hatched lines and shading. Sharpen the points of the sticks frequently to maintain a crisp drawing edge.

5 Now work on the crumpled paper bag, first defining the sharp creases with crisp lines and then using the side of the lead to define the soft folds and shadows. Continue working on the basket weave, firming up the underlying structure already established. Define the curves of the horizontal wickers, at the same time keeping in mind the curved shape of the basket itself. Note how the wickers appear smaller, darker and closer together as the basket curves round to the back.

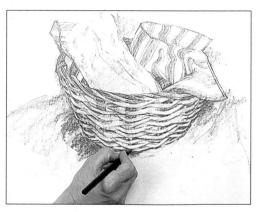

RAWING

Complete the basket by shading in the individual canes and wickers with finely hatched strokes, using the sharpened point of the 4B graphite stick. Add the dark tones between the wickers too, to give the basket depth and form. Use denser hatching where the basket curves away into the shadow at the back. Leave slivers of white paper for the tiny highlights on the wickers, or lift them out using the sharp corner of an eraser.

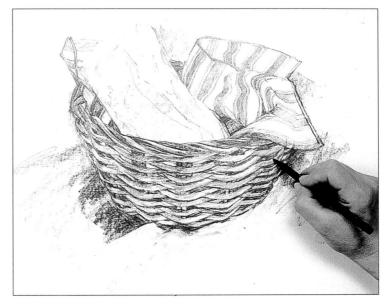

Helpful Hint GRAPHITE SMUDGES EASILY, SO TRY TO KEEP YOUR DRAWING HAND OFF YOUR WORK, OR LAY A SHEET OF PAPER OVER THE DRAWING AND REST YOUR HAND ON THAT.

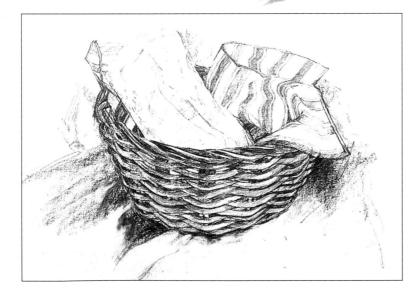

Finish off by suggesting a few more soft

shadows around and behind the basket with the side of the 6B graphite stick. These shadows should support and not overwhelm the main subject, so keep them light and sketchy. Once you've put in the final touches, fix the drawing with spray fixative to prevent smudging.

Index

Across the Fields by Sarah Donaldson 32 Angelini, Cristiana Gourds 56 Still Life with Dried Fruit 57 White Roses 80 Architectural Detail by Dennis Gilbert 44 Baker's Selection 58-61 Ballet Pumps 40-3 Beached Boats 45-9 blending 62-3 broken colour 50-1 By the Sea Shore 76-7 Canson paper 19, 80 Card Players by Philip Wildman 68 carpenters' pencils 11 cartridge paper 19 use with coloured pencils 27 Chair, Summer by Derek Daniells 50 chalk drawing 80 charcoal 12, 86 Citrus Fruits 85-9 Clouds and Rain 64-7 clutch pencils 11 colour blending 62-3 broken 50-1 complementary 50 white, seeing in colour 38-9 coloured pencils 11-12, 26-7 broken colour technique 51 complementary colours 50 conté crayons 14, 15, 56-7 drawing à trois crayons 57 papers 57 technique 57 crosshatching 27, 44, 57, 75

Daniells, Derek Chair, Summer 50 dip pens 16 Donaldson, Sarah Across the Fields 32 Nude Study 74 drawing board 19

Edgerton, Charmian Violin Practice 38 Elephants on Safari 33-7 equipment 10-19 erasers 19 effects with 32 Evening Light by Jackie Simmonds 62

Fazakerley, Pauline Limehouse Basin 20 Figure Study by Tiki Regwun 63 Five Greek Cats, Lindos by Jackie Simmonds 39 fixative 19 fountain pens 16 Freeman, Barry Winter Landscape 75 frottage 84 Fruits de Mct 81-3

Gilbert, Dennis Architectural Detail 44 Girl Resting by Maureen Jordan 51 Gourds by Cristiana Angelini 56 graphite 10, 90 sticks 11, 90

hard pastels 14-15 hard pencils 10-11, 20, 26 hatching 27, 44, 57, 75 Impressionists 50-1 Ingres paper 19, 80 inks 16-17 line and wash 69 water-soluble 16 waterproof 16

Jordan, Maureen Girl Resting 51

knives for sharpening and cutting 19

landscapes blending 62-3 Impressionists 50-1 Monet 39 'lead' pencils 10 *Limehouse Basin* by Pauline Fazakerley 20 line and wash 68-9 brushes 69 ink 69 pens 69

materials 10-19 Monet, Claude 39

Nude Study by Sarah Donaldson 74

oil pastels 15

paper 18-19 Canson 19, 80 cartridge 19, 27 charcoal and chalk 80 conté crayons 57 Ingres 19, 80 pastel work 19 stumps (torchons) 14, 19, 63, 75 textured 19

I N D E X

pastels 14-15 blending 63 broken colour 51 hard 14-15 oil 14, 15 paper 19 pencils 14, 15, 74-5 shades 15 soft 14 tints 15 use in creating white 39 wash effect 75 patterns frottage 84 pen-and-ink drawings crosshatching 44 pencils 10-13, 15 carpenters' 11 charcoal 12 clutch 11 coloured 11-12, 26-7, 51 grades 10, 20 hard 10-11, 20, 26 pastel 14, 15, 74-5 propelling 11 soft 11, 20, 26 water soluble 12 pens 16-17 line and wash 68-9

Reagan, Gail Still Life Study 90 Red Onions 70-3 Regwun, Tiki Figure Study 63 Rubens, Peter Paul 57

sandpaper blocks 19 Simmonds, Jackie Evening Light 62 Five Greek Cats, Lindos 39 smooth paper 19 smudging accidental in charcoal and chalk drawing 12, 80 soft pastels 14 soft pencils 11, 20, 26 Still Life Study by Gail Reagan 90 Still Life with Dried Fruit by Cristiana Angelini 57 Strother, Jane Study of Apples 27 Study in Textures, A 91 Study of Apples by Jane Strother 27

textures drawing paper 19 frottage 84 torchon 14, 19, 63, 75 *Tree Study* by Philip Wildman 84 *Tuscan Landscape* by Anna Wood 69

Vase of Petunias 28-31 Vegetable Basket 21-5 *Violin Practice* by Charmian Edgerton 38

water-soluble inks 16 water-soluble pencils 12 waterproof inks 16 white, seeing colour in 38-9 White House, The by Philip Wildman 26 White Roses by Cristiana Angelini 86 Wild Flower Field 52-5 Wildman, Philip Card Players 68 Tree Study 84 The White House 26 Winter Landscape by Barry Freeman 75 Wood, Anna Tuscan Landscape 69